ABANDONED
BATON ROUGE

ABANDONED
BATON ROUGE

STORIES FROM THE RUINS

COLLEEN KANE

AMERICA
THROUGH TIME®
ADDING COLOR TO AMERICAN HISTORY

America Through Time is an imprint of Fonthill Media LLC
www.through-time.com
office@through-time.com

Published by Arcadia Publishing by arrangement with Fonthill Media LLC
For all general information, please contact Arcadia Publishing:
Telephone: 843-853-2070
Fax: 843-853-0044
E-mail: sales@arcadiapublishing.com
For customer service and orders:
Toll-Free 1-888-313-2665

www.arcadiapublishing.com

First published 2018

ISBN 978-1-63500-074-0

Typeset in Trade Gothic 10pt on 15pt
Printed and bound in England

ACKNOWLEDGMENTS

With thanks to: Thaddeus, who is my first line of feedback, my photo editor, and my co-explorer at the Watson Motel, but more important, in life. Family and friends for the support (no small part which was babysitting while I researched and wrote): especially Mom, Dad, Annie, Kate, Bill, Sean, Liz, Mary, Jack, Leigh, ECS. Fiona, my little reader, for reading to herself as I finished this book in the final hours. All my co-explorers, numbering at least a dozen of the human variety, plus two canine exploring companions: Miss Addie and Miss Lola Mae. Those who gave me tours: at Cinclare, at the Bellemont, and especially LSU Facilities for hooking up a police escort for the pool. Librarians and archivists, especially Mark, and especially LSU Special Collections for allowing me to paw through boxes of dead people's fascinating items and papers. The Crusty Old Colonel, Butch, for introducing me to so many things Louisiana. Amanda for all the buddy passes. James Freeman for the always informative commentary. TigerDroppings.com for sending Abandoned Baton Rouge all that traffic through the years.

A warm thank you to the people of Baton Rouge, past and present, who gave tips, information, photos, time, introductions, meals, frosty beverages, and other help. And to all readers of Abandoned Baton Rouge, thank you so much for reading and adding to the conversation. Your comments have made this an endlessly rewarding project—not to mention that they were my first valuable clues about a lot of these places.

CONTENTS

INTRODUCTION

THE MOLD AND THE BEAUTIFUL

I t may be a florid capital city, but the Baton Rouge I know never fails to deliver on the dark and the strange. In 1699, French visitors called this place *baton rouge* after a boundary marker that was smeared with animal blood. So right from the earliest days, we're starting out with a bloody stick.

That odd factor was a good thing, more than a decade ago when I was a new Yankee in town. My blog, Abandoned Baton Rouge, was a morbid hobby born of desperate boredom. It proved to be an ideal combination of my interests: noticing old, weird things and investigating, looking behind the curtain, or in this case through a dirty window, and arranging my reality with the camera and in words.

In my neighborhood of Mid-City, I felt surrounded by blight, and I looked right at it instead of looking away. I started out on foot, not knowing anything about the city, using a hand-me-down digital camera that only took blue-tinted photos (Old Blue Eye). I acquired wheels (a 1970s Schwinn and a beater minivan), better cameras, and fellow explorers, and struck out further afield.

Of course, while Mid-City bumped up to a lot of decay, blight is far from the whole picture in Baton Rouge. It's a sprawling city with elegant antebellum homes, grand live oaks, effortlessly blooming flowers, colorful Craftsman and vernacular wood-frame houses, tracts of identical brick ranch homes, and strip malls without end. It can also feel like a small town. And in the sweltering heat of summer, it embodies a masterful description by Robert Penn Warren in *All the King's Men*: "the place where Time gets tangled up in its own feet and lies down like an old hound and gives up the struggle."

But my project helped me slow down and appreciate that Baton Rouge is a place to see in color. There's never been such a blue sky or such a golden golden hour.

As comments came in to my blog posts over months and years, adding context and background, I gradually came to realize these places were settings for parts of people's lives, even when no one was taking care of them anymore. In some cases, there were significant historic connections.

Although Baton Rouge never ceased with the strangeness, that began to feel familiar, and I pieced together my own map of the city supplemented with other people's memories. An ill-fated relationship (which left me rich in material to mine, if nothing else) brought me to this place I never would have lived otherwise, and it changed my life for the better.

I moved back North, but new readers kept finding Abandoned Baton Rouge, leaving comments and following the Facebook profile. I made a few return visits to Baton Rouge and made some more posts.

Revisiting the city and the subjects to write this book has been just the kind of work I love: getting immersed, following clues, and being rewarded with gems.

Looking through the blog again, I remembered a place that any old time I looked, never failed to casually supply something weird.

But this go-round, I sought information beyond what a simple Google search would reveal. The resulting tour of forgotten, neglected, and some now-demolished sites involves film stars, famous athletes, a legendary politician, civil rights leaders, a disgraced televangelist, the Beatles, the Rolling Stones, the somewhat lesser-known rock and rollers the Basement Wall, an engagement, an assassination, and several murders. Put together, you get a story of a city.

In Baton Rouge, history doesn't always stay in the past, if you're looking closely enough. Sometimes it hasn't even gotten there yet.

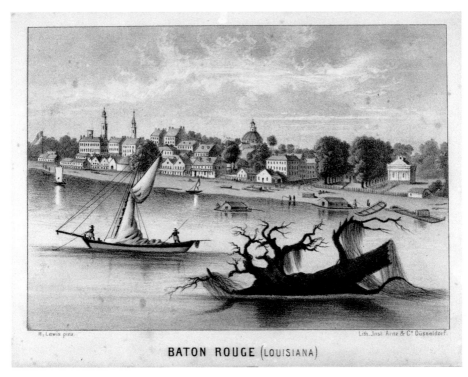

BATON ROUGE (LOUISIANA)

Above: Starting with Baton Rouge's eponymous blood-red stick, through post-Antebellum decay and into the modern age, there's always been a dark side to this area. As can be seen in this print, even back in the 1850s, the plants were creeping. (*From the Miriam and Ira D. Wallach Division of Art, Prints and Photographs: Print Collection, The New York Public Library. "Baton Rouge [Louisiana]." The New York Public Library Digital Collections, 1854-1857*)

Below: A mom and pop corner store since the 1920s, Lobianco's Grocery and Beer was pictured here in 2011, when it had been closed for well over a decade. Old Joe Lobianco's grand-niece remembered drinking "ice cold bottled Cokes, not canned, out of the machine" with her sisters when visiting the store, while he regaled them with stories. It looked like an unlikely relic when I first saw it in 2007, and now it's gone.

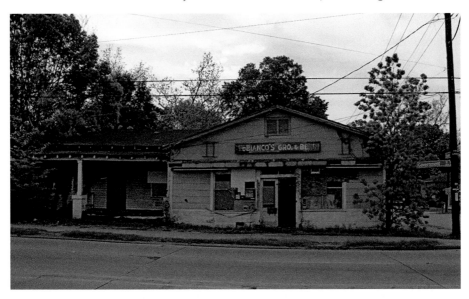

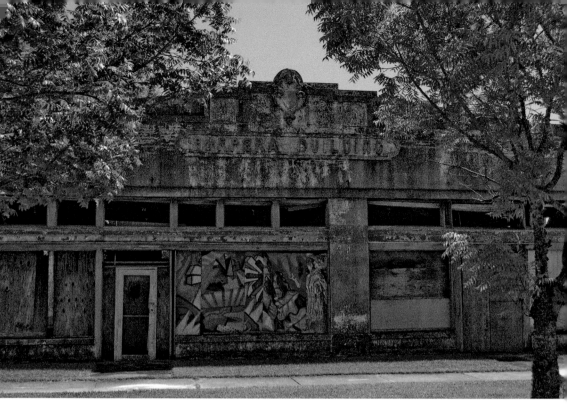

Above: The Purpera Building, pictured in 2018. From 1955 through the mid-1970s, Carlo Bonura operated a drinking establishment called Vince's Bar and Lounge in this building. Typical patrons at its mahogany bar were local politicians and Holsum Bread employees. It also had a player piano, sports scores that arrived over ticker-tape, and "the best roast beef po'boys in town," according to Bonura's daughter Donna Lensing.[1]

Below: An older photo I took of the presumably abandoned Leo's roller rink makes a brief appearance in the 2018 documentary *United Skates,* as one example of the many ex-roller rinks across America. (The other two local Leo's rinks just closed permanently after about seventy years in business.) In 2018, this original Leo's is in use: the building belongs to a church and is being rented out for storage.

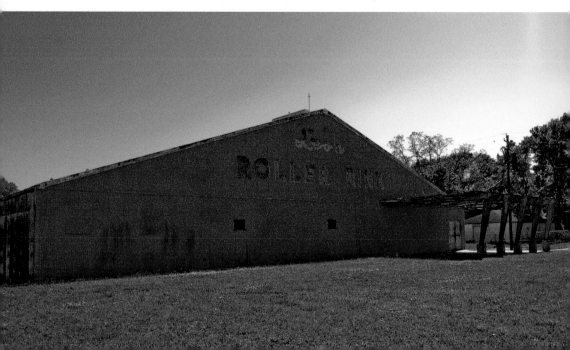

Above: Abandoned? Hard to say sometimes, even when there's a tree growing out of the building.

Right: Definitely abandoned: the Watson Motel, 2015. It has since been demolished.

1

CHECK OUT AT THE BELLEMONT

When Airline Highway was completed in 1953, it provided a more direct way for motorists to shoot from Baton Rouge down to New Orleans. It had plenty of neon-signed roadside lodging options, but the belle of them all was the Bellemont.

Built in 1946 by real estate magnate Arthur Cullen Lewis, Jr., who also owned the Continental Hotel and the Oak Lodge, it started out as a low-slung "motor hotel" with a taller, antebellum-inspired central lobby. Over the next decades, it developed into a multi-winged complex over 18 acres, as successive postcards advertised first 200 rooms, then 250, then 400 rooms.

A breathless *Register* puff piece from 1957 (one of three that ran in Baton Rouge's society magazine that year) describes the Bellemont as a "complete village in itself," with completed or in-progress beauty shop, barber shop, flower and gift shop, haberdashery, drug store, and a coffee shop that had no locks because it never closed.

The Bellemont's crown jewel was the then-brand-new honeymoon suite, the Pan American, featuring its own private pool, plus a sitting room looking onto the pool with floor-to-12-foot-ceiling windows and a Mayan-motif cast-stone fireplace. Hold onto your haberdashery: in 1957 this exclusive level of luxury ran 150 dollars a night (more than $1,300 in 2018 dollars). The rate for the motor lodge's other rooms was as low as $5 per night (or about $45, adjusted for inflation).

Also, at that time, there was an Esso Suite (not to be confused with The Petroleum Suite), featuring a mosaic panel that depicted the oil industry's growth, plus a private bar so that guests might sip a cocktail while contemplating this artwork by a South American

artist. The Executive Suite had a 35-foot living room and a foyer for a receptionist or secretary's station. The Planter's Room was a lounge with a plantation-themed mural behind the bar, and the Continental Room could host wedding receptions and other events with up to 350 guests.

Verna Bradley-Jackson worked at the Bellemont for twenty-six years, from 1984 until 2010, beginning as a porter, and concluding as the operating manager/president of the Great Hall, the Bellemont's event space that served up to 2000. Her husband Tommy Jackson started working there in 1983, setting up banquets, and ended as the vice president. They speak in glowing terms of their former workplace and coworkers.

"It set the standards for the city of Baton Rouge," Bradley-Jackson said.

"Everybody who was somebody or wanted to be somebody, you had to come there," Jackson said. Those somebodies included then-Vice President George Bush, Jane Fonda, Paul Newman, Irma Thomas, John Wayne, and Clint Eastwood. Clark Gable stayed for a month in the Governor's Suite while shooting *Band of Angels*. Richard Pryor stayed for five weeks while filming *The Toy*. Other movie casts and crews that bunked at the Bellemont include *Freedom Road* (Kris Kristofferson/ Muhammad Ali), *Mandingo*, *The Beguiled*, *The Undefeated*, *Desire in the Dust*, and *Hurry Sundown*. New employees were given a list of celebrities who had stayed at the Bellemont, as part of their orientation.

In 1964, two very famous Hollywood stars who very famously did not get along, Bette Davis and Joan Crawford, stayed at the Bellemont while filming the Southern Gothic thriller *Hush, Hush, Sweet Charlotte*. The whole company stayed there, each in their own bungalow, according to the book, *Bette and Joan: The Divine Feud*, because "the accommodations were always first class" with director Bob Aldrich, said Bob Gary, the script supervisor for the movie.[1] (No freestanding bungalows existed at the Bellemont in its last few decades, nor have I encountered any other mentions of them. In one existing 1950s Bellemont postcard image, the lodgings depicted with individual awnings over their doors might have been considered attached bungalows.)

The book tells of Davis hosting a party for co-star Mary Astor, to which their director and all of their co-stars were invited, except Crawford. When Davis hit the town to watch Phyllis Diller perform, Crawford stayed back at her Bellemont bungalow, as vodka bottles piled up outside the door. It's too much drama to report here (and if you're into that sort of thing, there's a whole book and TV series about it, and probably even some live drag show interpretations), but Crawford did not stay on the picture.

More than a few of Baton Rouge's failed businesses (now abandoned buildings) can blame the coming of Interstate for their undoing. By the mid-1970s, changes brought

by the newly built I-10 were afoot in Baton Rouge, and that impact was certainly felt on Airline Highway. Baton Rouge's center of business and activity shifted further south, where more modern hotel accommodations were cropping up.

The Bellemont's long and slow decline can be traced to that period. The rambling complex had expanded so much that it was costly to keep it all running. Plus, it had the flat roofs favored by midcentury architects that can mean trouble for long-term maintenance.

To reinvigorate business, the Great Hall was added in 1984, offering the largest convention hall in town, where it hosted debutante balls, weddings, and proms. It did work to drive business, for a while.

All sorts of events were held at the Great Hall: benefit performances hosted in different years by Bob Hope, George Burns, and Tony Orlando; a Caged Bird Show, Sale, and Swap; and a Ron Paul campaign stop in 2008. In 2005, the Great Hall hosted nearly 3,000 for the viewing and funeral of Jackie Neal, a murdered Baton Rouge blues singer and daughter of bluesman Raful Neal.

"We worked around the clock then, the lights never went out," Jackson said.

"Exxon, Coca-Cola, conferences from all over... all balls were held there from the Saturday after Thanksgiving through a week or two before Mardi Gras," she said. "Every major ball that took place in the city was held there."

But the writing was on the wall after A. C. Lewis died in 1985. In 1986, the property went bankrupt and it changed hands several times.

One of those changes was a 1993 $1.325 million sale, mostly in cash, to the World Plan Executive Council-US, followers of the Maharishi Mahesh Yogi, who you might recall from that time the Beatles went to India and wrote most of *The White Album*.[2] The group operated the hotel (and others in other cities) using the management name Heaven on Earth. (Abandoned Beatles side note: the ashram where the Beatles studied Transcendental Meditation with the Maharishi in 1968 was abandoned in the 1990s and overrun with jungle growth until 2015, when it reopened as Beatles Ashram.)

Meanwhile, the surrounding area was taking a turn for the worse.

There was even a deadly shooting in the parking lot outside the Great Hall. In 1998, twenty-one-year-old Cecil W. Augustus, Jr. got in an argument with a group of men after a concert and a fistfight broke out. One of the men shot Augustus, who died in his car.

Bradley-Jackson recalled exact dates for almost everything she mentioned, but there is one date a lot of people in Louisiana won't forget. "August 30, 2005. At 5 p.m., Camelot College was having their graduation, we had to ask them to clear out so we could unload 22 buses, because they [hurricane Katrina evacuees] had nowhere to go," she said. Thus

began the Bellemont's several-month stint as one of the staging sites for Katrina victims and emergency personnel. "We fed them grits, eggs, we gave them four-course meals."

That was reimbursed by FEMA, but Jackson and Bradley-Jackson also said they extended charity from the Bellemont kitchen to individual homeless people who were hungry, and even changed some of their lives.

When I first encountered the site in 2008, from the looks of the lobby, the lodging appeared to be very much an ex-business, with plaster falling from the ceiling and a living carpet of moss and mold. But on closer inspection, the Great Hall was locked up and seemed intact. And on further exploration, the guest rooms were not all vacant. Some units appeared to have occupants, and other units were perhaps being used for "hourly"-style purposes.

I filled up two camera memory cards on my first visit, but it felt like only scratching the surface. The site became a favorite of all the locations I featured on the Abandoned Baton Rouge blog.

In 2009, T. Joseph Calloway purchased the whole 18-acre package for $535,000.[3] The Great Hall closed for good the following year.

In May of 2012, I had returned to living in Brooklyn, but after I heard the Bellemont's demolition had begun, I booked a flight to Louisiana. That's when I really got to know the Bellemont. This time I had unrestricted access, thanks to demolition crew leader Charlie Hayden of Busted Knuckle Field Services.

The site was enormous. Resorts and large complexes are so much fun to explore because they offer a little of everything: bedrooms, restaurants, shops, entertainment, and recreational facilities. And there are so many memories associated with them. Multitudes of people from all levels of society had scenes of their lives set here: from oil executives to destitute squatters, from ticket holders at the old-fashioned debutante balls to lonely hearts just trying to score at Brellas lounge.

Even during demolition (Busted Knuckle worked on it for several months before an abatement company took over), The Bellemont was still in use by non-paying customers.

"Every morning when we got there we had to go through and get everybody out," said Hayden, who brought two pistols daily, one that he carried and one to arm a crew member. "People sleeping there, people doing drugs, people selling drugs. There was a trailer park in that area. Once a week we'd tell them, everybody that wants to work, come over on Monday morning, and that's who's going to work for the week. But half of them was the people that we was running out of the hotel."

Much like the motor hotel guests, in the end many pieces of the building and its contents went their separate ways. Hayden sold off some items, either for scrap, or to

be repurposed somewhere else, or as souvenirs. Plenty of items and parts disappeared when no one was watching. "There were about 40 air conditioners on the back of the Great Hall, and I don't think you could put one together from the parts that were left," Hayden said.

Even during its destruction, the Bellemont embodied some of the greatest hits of Baton Rouge of today—The oil money! The movie business! The Geaux Tigers!—and also its problems.

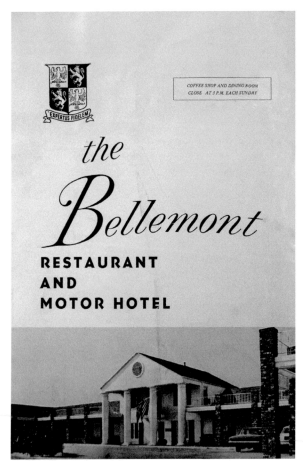

A vintage room service menu from the Bellemont, kept in the East Baton Rouge Parish Library archives, offered a large seafood gumbo for $2.95 and a 10-ounce ribeye steak for $7.95 (menu items also available for about 10% cheaper in the dining room).

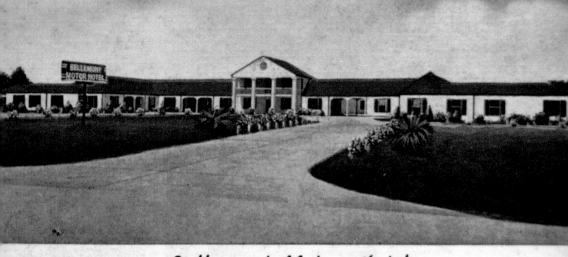

Bellemont Motor Hotel

"Luxury Accommodations for Discriminating Guests"
On By Pass Routes U. S. Highways 61, 65, 71 and 190, Baton Rouge, La.

Above: This early view, probably from the late 1940s, shows the original modest configuration of the motor hotel. The later postcard shown in this section depicts a bigger, Atomic Age neon roadside sign and the first signs of the Bellemont's exterior brick motif. (*Postcard: author's collection*)

Below: View of the Bellemont from Airline Highway in 2012. The road also known as Highway 61 once brought celebrities and other high-profile clientele, but the coming of the Interstate moved the economic center away. Not shown: the Great Hall was at the far left.

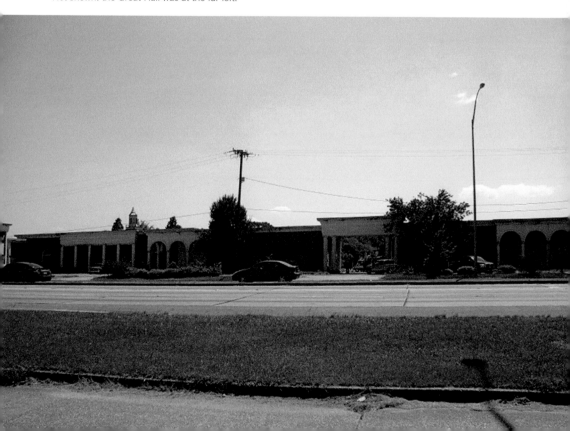

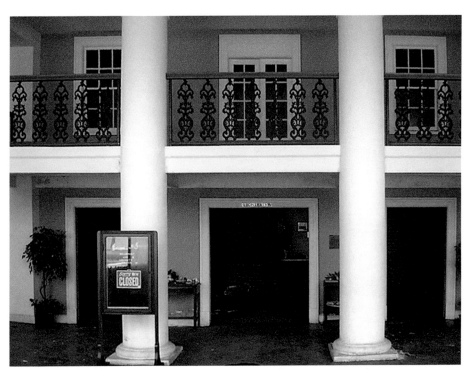

Above: The Bellemont's lobby during my first visit in 2008. Comparing this view to early postcard images, you can see this glass-fronted enclosed lobby area used to be the open-air main entrance.

Below: That eye-level view of the lobby in 2008 appeared intact, but this view was also the lobby during my first visit: a living carpet of moss and mold. If you looked up, the plaster was falling from the ceiling.

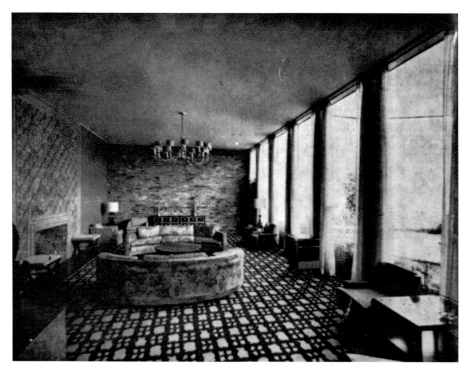

Above: The Pan American Suite sitting room in its glory days.

Below: The once-luxurious and pricey Pan American honeymoon suite during its final days in 2012, with encroaching plant growth. In 1957 a night here ran $150, or more than 1,300 in 2018 dollars.

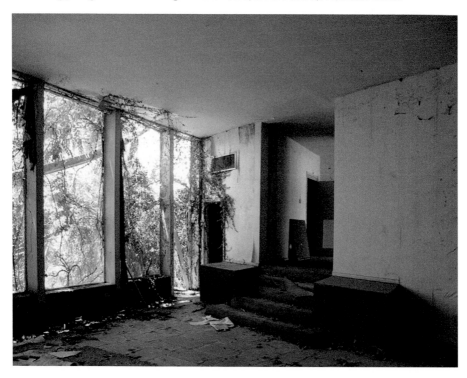

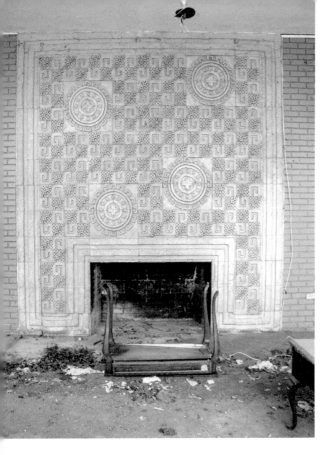

Left: The Mayan cast stone fireplace of the Pan American Suite in 2012.

Below: The Pan American's suite private pool. How many of its swimmers were naked? Probably all of them.

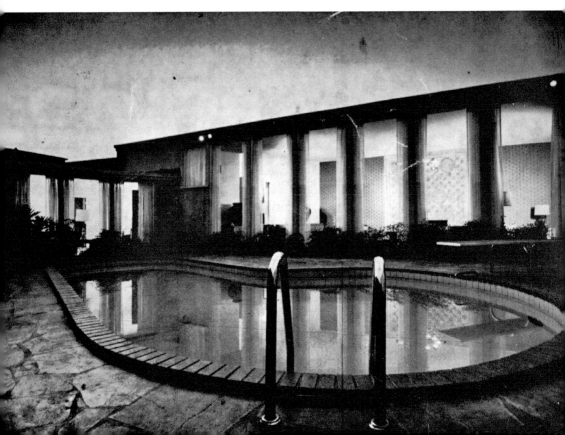

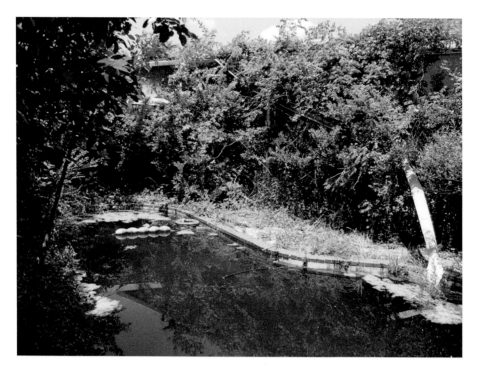

Above: The Pan American Suite's pool in 2012. Early publicity for the Pan American Suite extolled the beauty of the pool patio's abstract South American mosaic made from vibrant Italian tile. In 2012, heavy vine growth almost completely obscured the tiles. Outreach efforts to preserve the mosaic during demolition were unsuccessful.

Below: When feuding actors Bette Davis and Joan Crawford stayed here in the 1960s to film a movie, Crawford arrived days after the cast and crew, and her bed hadn't been made up. After waiting in the lobby for an hour, she got a bungalow across from Davis' larger one, next to a trash disposal unit. After Crawford complained, Bette Davis reportedly said, "Oh Joan! Pull yourself *together*. This is Baton Rouge, *not* Beverly Hills."[4] (*Postcard: author's collection*)

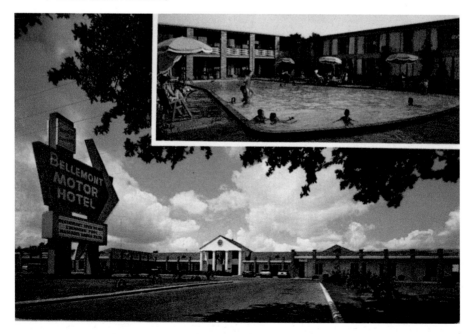

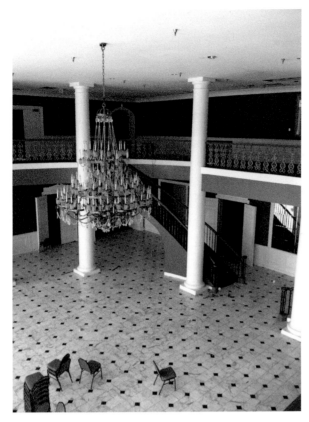

Left: A. C. Lewis, Jr. based the Great Hall on the design of his house, Charbonnet, which can be seen as the main location for the 1982 comedy *The Toy* (along with other vintage views of Baton Rouge, including Goudchaux department store). One similarity was the marble floor tile pattern of the grand foyers. Stars Richard Pryor and Jackie Gleason stayed at the Bellemont during filming, and some scenes were also shot at the Bellemont.

Below: A Bellemont guest room overtaken by mold in the rear section in 2008. You could smell it from outside the room.

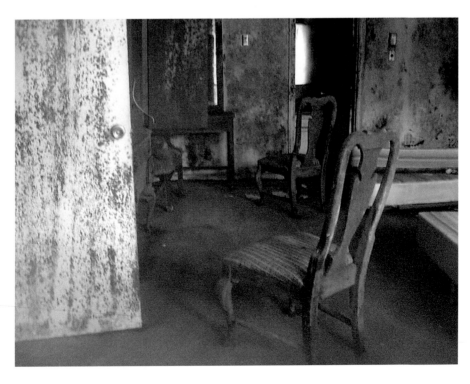

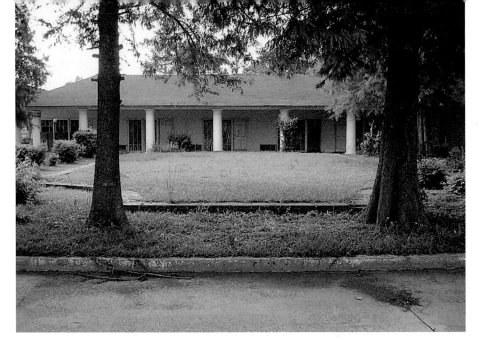

Above: Colonial section lawn. The Bellemont became a movie star itself when it was used as a location in movie shoots: it was most prominently featured in the 2011 Patrick Dempsey and Ashley Judd bank heist caper *Flypaper*, where the Great Hall starred as the bank. In the 2012 Jean-Claude Van Damme flick *Dragon Eyes*, look for the brick arches in the background while someone is getting their ass kicked, and in the 2010 Ellen Barkin and Famke Janssen drama *The Chameleon*, a section of guest rooms stood in as apartments.

Below: This LSU Tigers mural at the Bellemont, shown when it was new in the 1960s, depicts a crucial play known as "The Stop" from the 1959 LSU vs. Ole Miss game. Standing in front of their likenesses are none other than Billy Cannon (far left) and Warren Rabb (second from left). (*Courtesy Greg Stahlnecker, Jr.*)

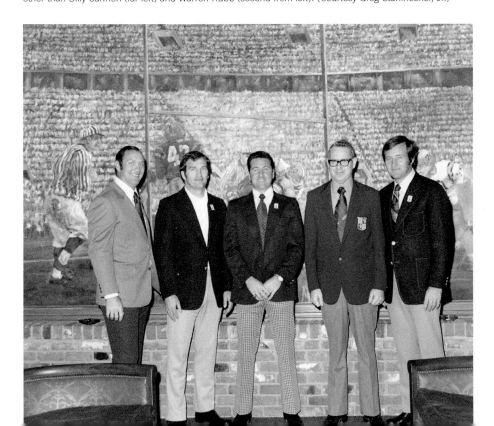

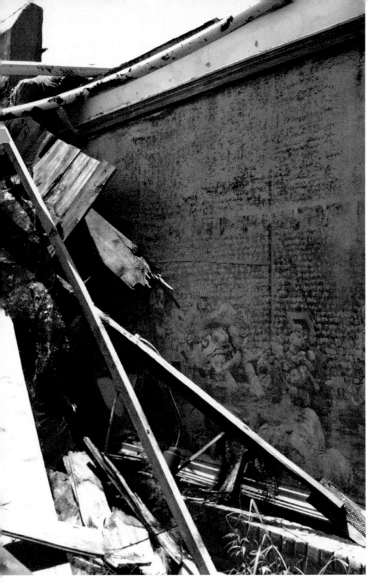

Left: On the day he learned of the demolition, Greg Stahlnecker, Jr., a collector of LSU memorabilia, went to the Bellemont and got permission to take the Stop mural. Charlie Hayden from the demo team loaned the services of his brother, a ladder, and two box cutters. "I then stored the mural unsure of what I would do with it," Stahlnecker said. After posting his prize on the message board TigerDroppings.com, many people asked to purchase it. (*Photo by Greg Stahlnecker, Jr.*)

Below: What's left of "The Stop" mural from The Bellemont after sitting under several feet of water during the 2016 Louisiana floods. "I'd love to have it recreated since its condition is so poor," Stahlnecker said. This is after it was already exposed to the elements for years. The roof over it had caved in sometime before 2008 when I first photographed it. "I truly wish I had gone a few years sooner, before the roof caved in," he said.
(*Photo by Greg Stahlnecker, Jr.*)

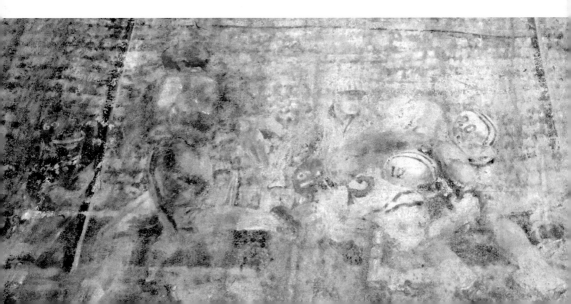

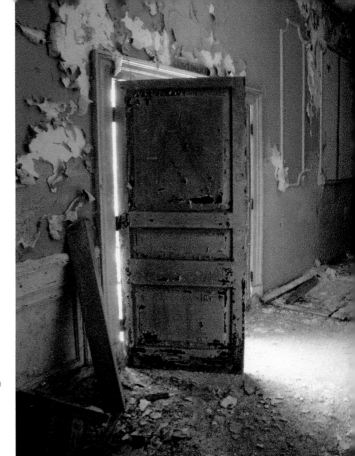

Right: Pink peeling walls in 2012.

Below: The 75-foot pool, one of two for general guest use, in 1954. Postcard photo by photographer Woody Ogden, who also shot the other Bellemont (now Days Inn) further east on Highway 61, in Natchez, Mississippi. That one was also modeled after A. C. Lewis' Charbonnet, and had a similar pool. (*Author's postcard reproduced with permission from Ogden family*)

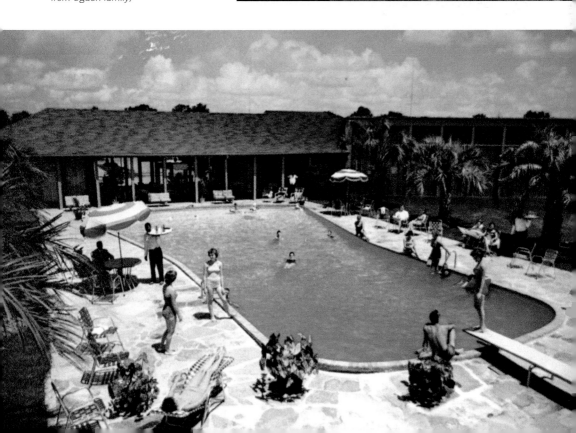

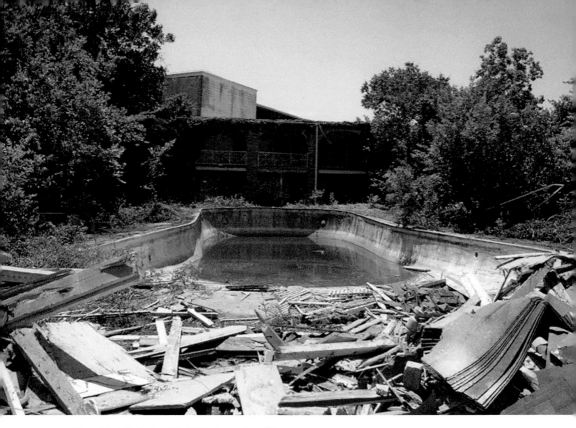

Above: That 75-foot pool in 2012 during demolition.

Below: I took some paper souvenirs from the demolition site. "We left a lot of stuff behind, there was no use to carry it out," said Verna Bradley-Jackson, who was the Great Hall's operating manager and president at the time of closing. I found Verna's old business card during demolition, held onto it, then looked her up to talk for this book.

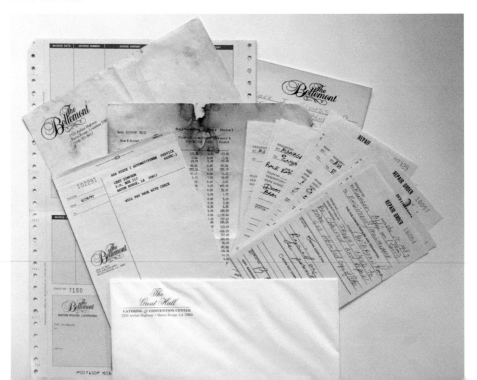

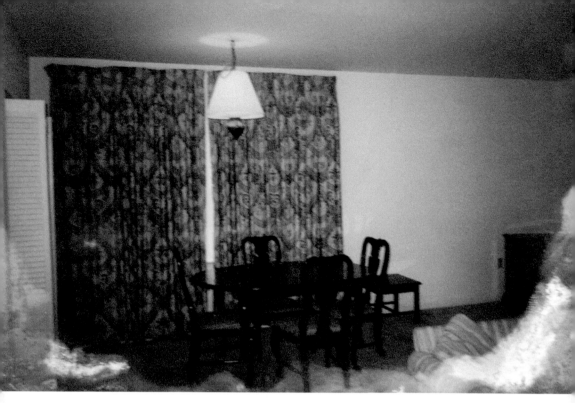

Above: This photo print found at the demolition site shows the dining area of a deluxe suite at The Bellemont in 2000.

Below: A map of The Bellemont campus. The Great Hall is at the lower left, lobby and reception are at lower center of map.

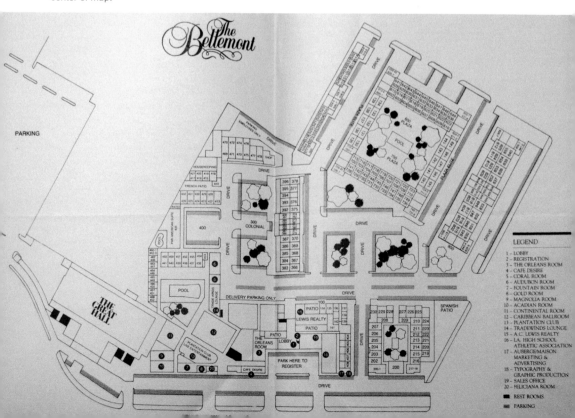

LEGEND

1 – LOBBY
2 – REGISTRATION
3 – THE ORLEANS ROOM
4 – CAFE DESIRE
5 – CORAL ROOM
6 – AUDUBON ROOM
7 – FOUNTAIN ROOM
8 – GOLD ROOM
9 – MAGNOLIA ROOM
10 – ACADIAN ROOM
11 – CONTINENTAL ROOM
12 – CARIBBEAN BALLROOM
13 – PLANTATION CLUB
14 – TRADEWINDS LOUNGE
15 – A.C. LEWIS REALTY
16 – L.A. HIGH SCHOOL
 ATHLETIC ASSOCIATION
17 – AUBERGE/MAISON
 MARKETING &
 ADVERTISING
18 – TYPOGRAPHY &
 GRAPHIC PRODUCTION
19 – SALES OFFICE
20 – FELICIANA ROOM

■■ REST ROOMS
▨ PARKING

This small courtyard toward the back of the complex, the French Patio, had spent the years silently becoming a jungle.

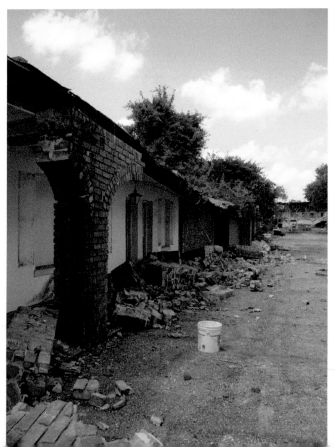

"We sold all the bricks," said Charlie Hayden, who led the demolition. "The old part was mostly the solid bricks," he said, "We made maybe $1,200 a week just on the bricks. We had a whole other crew cleaning the bricks and putting them in piles." However, Bradley-Jackson said, "Some of those bricks were slave bricks. People didn't know what they were tearing down."

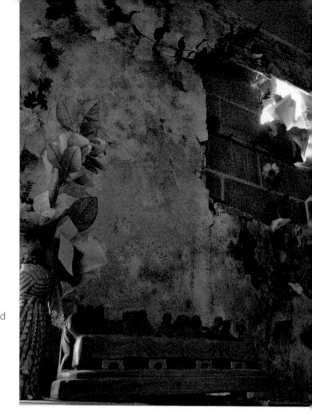

Right: Plastic flowers and mold blooms at the Bellemont's chapel.

Below: Vines overtake the upper 600 block of rooms. "That place was built really really expensive," Hayden said. Although thieves had made off with nearly all the copper wiring, they had missed a copper-topped bar, and left the copper gutters untouched, probably unnoticed because they had oxidized to green. The demolition crew used a bulldozer to access the remaining copper wiring leading underground from the Great Hall to the main transformer—about $40,000 worth.

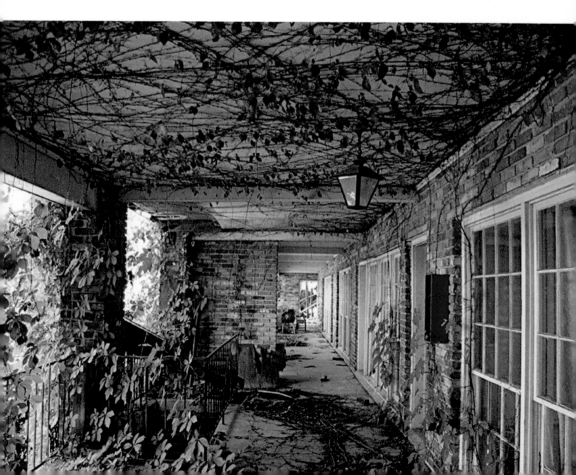

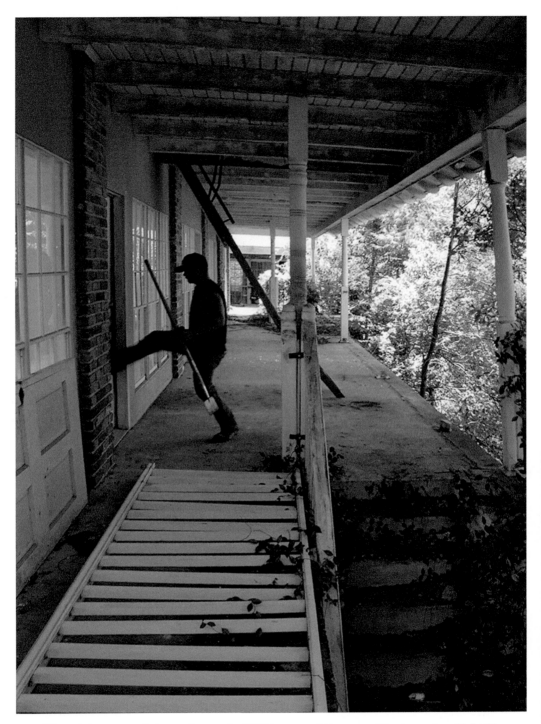

"The state troopers wanted some doors so the SWAT teams would have something to practice with," said Hayden. "We donated 38 of the hotel doors so they could tear them up with the door ram. We did that as a tax write-off. We didn't even have to take them apart because they got inmates to come and take them off the walls."

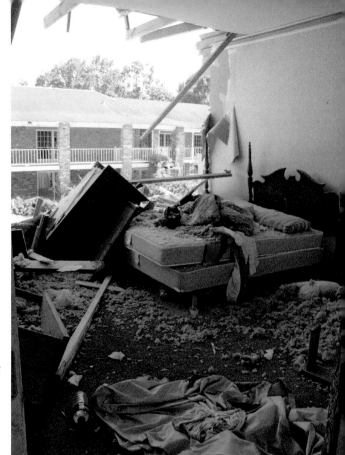

Right: A room with a view.

Below: Overview of the grounds of the Bellemont in 2018, photographed from the temporarily abandoned Salvation Army complex across Airline Highway. Behind me, under renovations, was the halfway house parking lot where Barry Seal, the Baton Rouge pilot-turned-drug smuggler-turned government informant, was assassinated by machine gun in 1986.

Above: Some of the remaining marble flooring of the Great Hall in 2018.

Below: This was the Bellemont. It was a special place to almost everyone who spoke or commented about it. "Nowhere on the ground will there ever be a place like that again," said Tommy Jackson, former vice president of the Great Hall. "Not on this earth."

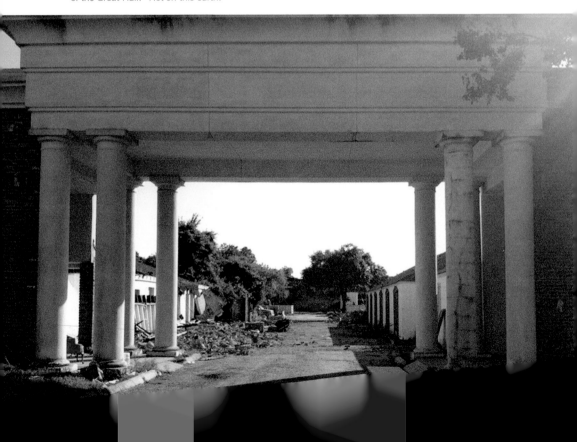

2

EVERYBODY OUT OF THE POOL

Louisiana State University has numerous grand-scale features not seen on other campuses: It's shaded by ranks of magnificent old live oaks, Tiger Stadium seats more than 100,000 fans, and just across the way from it is an arena where the Rolling Stones kicked off their 1975 tour and where many other major acts have performed. Also, there is a big ol' tiger mascot named Mike living in a custom habitat.

But if you didn't know it was there, you might not notice the beautiful ruin hidden amidst all of those things, once believed to be the biggest of its kind. It's the Huey P. Long Field House Pool, where at one time all students were required to take a swim class.

The Field House was LSU's first student union. It opened in 1932 as the governor was shepherding the state university from small-time player into the big leagues, and building out the campus to his specifications. It had a post office, soda fountain, ballroom, and athletic dormitories. Extending out from the back was the open-air Huey P. Long swimming pool.

When Huey Long built the new Louisiana state capitol building, it had to be the tallest one in the United States. And when he built this pool, it had to be the largest.

So at 180 feet, it's a non-standard length. It's longer than an Olympic size, which is 164 feet or 50 meters. How did the Long pool get to be so long? Some of the specifics depend on who you ask, but the short answer is, "because Huey Long."

Bill Bankhead is in his 80s now, and first swam in the pool "as a youngster," then went on to become LSU's second aquatics director in 1960 and helped bring back LSU's competitive swimming, which had disappeared during World War II. The first aquatics

director when the pool was built was W. G. "Higgy" Higgenbotham, who also helped bring the first Mike the Tiger to campus.

Bankhead heard the commonly told version from Higgy: the pool was almost finished being built when Huey Long came by with the contractor, he asked if it was the biggest in the country, and they said no, that some other school (everyone's story names a different institution's pool) had a 50-meter pool. Huey asked how long that was, they told him about 55 yards, and he said, "Tear the end out, make mine 60."

Then there's another story, found in an undated narrative, written longhand in pencil by James Monroe Smith, who was appointed president of Louisiana State University by Long in 1931 (a position he held until 1939 when he was implicated in a scandal involving misappropriation of funds):

The story concerning Huey Long and the swimming pool ... has had wide circulation but is incorrect. When the plans were completed by the architects he made inquiry as to the length and depth of the pool and was informed that it would be 12 feet in depth at the deepest point and would be 180 feet long which was thought to be equal in depth and length to the largest outdoor pool in the country, he said, "Why have it equal in length, why not have it longer? Add five feet and hang the cost." The five feet were added and the Huey P. Long swimming pool remains the longest outdoor swimming pool in the nation.[1]

A contemporaneous account in the newspaper painted a more theatrical variation:

The idea for the pool came from Major Middleton, the ROTC commandant, who proposed it to George Everett on the board of supervisors. Together Middleton and Everett worked out a plan that would cost seventy-five thousand dollars. Everett took the plan to Huey and explained that it was Middleton's. Huey sniffed. "Hell," he said. "He don't know nothing about pools, but I do."

Quickly he sketched a design for one that would cost half a million dollars and directed that it would be built adjacent to the field house. One day when the pool was being constructed, Huey appeared in Middleton's office. "Major," he said, "let's go over and see that swimmin' hole of yours." As he walked along the edge of the project, he asked if this was the longest pool in the country. Middleton said he thought the one at the United States Naval Academy was a little longer. Huey turned to the construction foreman. "Put ten more feet on this pool," he ordered. When completed, the pool was was 180 feet long and 48 feet wide—and in Louisiana was believed to be not only the largest in the country but in the world.[2]

Having the biggest pool wasn't really a benefit for anyone other than the guy who wanted the biggest pool. For 50-meter races, swimmers had to finish under a rope, then in later years they finished at a bulkhead.

Also, because of the extra length, the point where divers went into the water was not the deepest part of the pool. It was far too shallow, so they often sliced through the water and hit the bottom hard. Mike Dooley, who was a diver on the LSU swim team from 1969 through 1974, dislocated his shoulder a lot this way. He said the visiting teams were warned about the depth but would forget during competition, and he saw one swimmer come up "swimming in little bitty circles ... It's fortunate no one broke their neck. Eventually they wised up and took the diving boards out."

Monroe added this defense of Long to his pool account: "For those who might be inclined to criticize I offer the simple statement that Huey Long was no ordinary individual, but an individual of great will power, determination and genius, who held within his hands practically absolute power within the state, and who if his interests were properly guided, could bring about the constructive development of a great University."

And at least according to former LSU associate professor of the Department of Agricultural Economics and Agribusiness, Wayne Gauthier, some quality literature could have been partially inspired by the pool's creation. He said in a 2014 interview that Long appropriated funds from *The Southern Review* to construct the pool. The defunded literary magazine was the baby of cofounder Robert Penn Warren, who later wrote *All the King's Men*, a novel centered on a fictionalized and rather very Long-like character.[3]

Around 1964, after LSU decided to accept black students, Bill Bankhead recalled that he showed up to work at the pool and found it empty. The maintenance department told him they had drained it, but couldn't give him any information. So Bankhead and his department head went to the university president's office, which was filled with politicians.

"They told me that the reason they had drained it was that there was an earthquake in Alaska and it had cracked the pool, and they had to drain the pool to see what the damage was and further didn't know when it would be fixed," Bankhead said.

"Of course what had happened was a black graduate student had enrolled for the first time at LSU. They were afraid he was going to come in and swim either if he had a class or went into the pool for recreation." The pool stayed closed most of that summer, until they opened it for classes later in the season.

At that time, Bankhead remembers that the enormous pool at City Park was filled in rather than allowing black people to swim in it, and then private swim clubs emerged that didn't permit blacks. The next summer he started the Bengal Swimmers, to teach kids to swim, as the first local non-private swim club.

Mike Dooley lived in the Field House during his time at LSU. He occupied the former coach's locker room, and although he had several roommates over the years, he said "usually no one could take it. It didn't have air conditioning, it was pretty isolated. No one liked it but me, I loved the independence and the solitude."

His pool-proximate accommodation came with responsibilities. "I was kind of a night watchman," he said, booting out rogue night swimmers, and he had to supervise the basketball gym downstairs, often unlocking the doors for legendary LSU baller Pete Maravich late at night. "The guy was just burning up to play basketball all the time." (The assembly center just beyond the end of the pool is now named for Maravich.)

The "new" student union opened in 1964, ending the era of the Field House as a student hub. When the campus' indoor natatorium opened in 1985, it was the first real nail in the coffin for the Huey Long pool. The Field House main building is still in use with the school of Kinesiology and the School of Social Work, but is in dire need of an overhaul. The pool and other facilities like the racquetball courts closed in 2003 when leaks emerged in the pool that would have been costly to repair. The structure has been deteriorating ever since.

The 2017 debut of the outdoor pools at the UREC complex, with an "LSU"-shaped lazy river, makes the notion of reviving the Huey Long Pool for recreational swimming redundant.

So, what now? The Field House and pool are included in the Louisiana State University National Register Historic District, so the wrecking ball is not too likely.

A master plan was announced in 2014, designed by Tipton Associates (who restored the Varsity Theater, the former movie house just off campus), which would fill in most of the pool as a meditative, parklike space that would leave part of one lane open and filled with water as a tribute. The project was contingent on raising $18 million. At press time, a spokesperson for LSU said the plan was "on the state's list of priorities, and [it] awaits funding approval."

Even the man who said, "I can't imagine anyone being more interested in the pool than I am," and "they had to force me out of there, I did not want to leave," Mike Dooley, doesn't feel the Long pool should be preserved as a swimming facility. "I think even the original pool was asking for trouble, because of that balcony." He remembers during his college days watching a drunk student jump from an even higher perch, the roof, about 25 feet above the deck, and barely making it into the pool.

"You just can't set up a situation where a 19-year old college kid has the ability to jump off into that pool from the roof. You just can't do that anymore. The university would be sued and they would deserve to be sued."

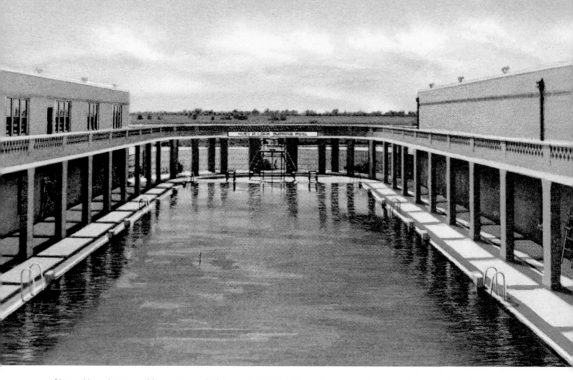

Above: Huey Long pool is an unusual size, and stories differ on how it got that way. It was designed by Leon C. Weiss, the architect behind many Long administration buildings, including numerous LSU structures and the iconic Art Deco state capitol. His firm Weiss, Dreyfous, and Seifirth also designed Charity Hospital, New Orleans' Art Deco beauty that's been vacant since Hurricane Katrina. He was later convicted in the 1939 "Louisiana Hayride" scandals and served several years in prison. (*Postcard: Curt Teich Company*)

Below: Former aquatics director Bill Bankhead remembers when the pool had a dome. "Swimming is in the wintertime and it was an outdoor pool, so when we hired the first varsity coach, Ted Stickles, we put an air dome over the pool. And that lasted until a few years later when we had a hurricane and it blew it apart." The pool is pictured here in 2009.

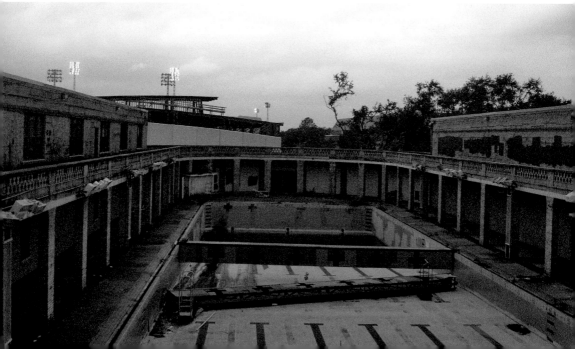

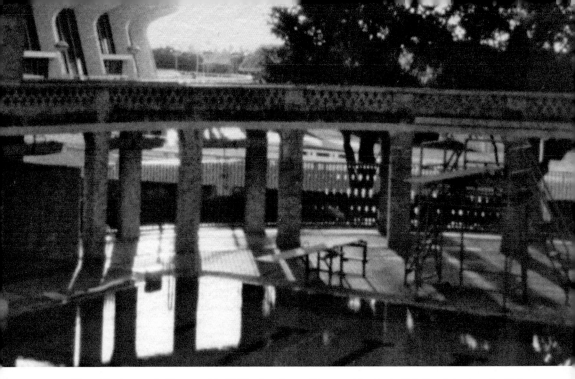

Above: The long end of Long pool in 1972, when it was still open at the back. Note the diving board, which former LSU diver Mike Dooley called "archaic." "Even then it was really old." (*Mike Dooley*)

Below: "That balcony ... was probably not a good idea at a college because we were jumping off that balcony [into the pool] all the time," Dooley said. "Everyone did it." (*Mike Dooley*)

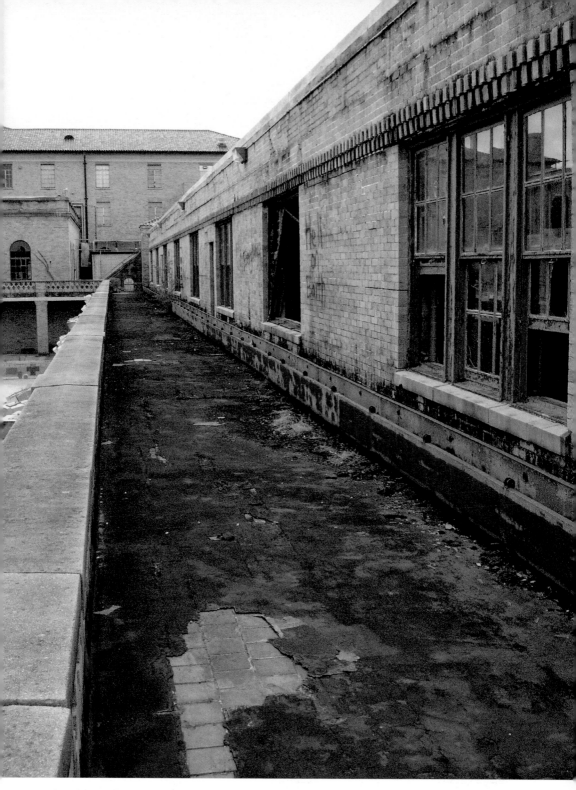

One of the pool's most charming features, the gallery, goes around three sides, and there is an inner walkway on two sides as well.

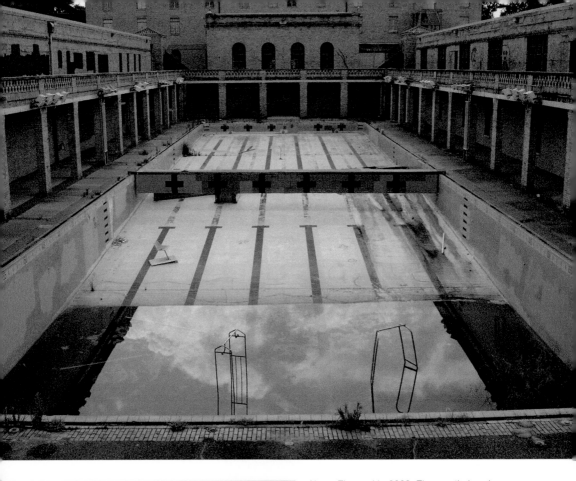

Above: The pool in 2009. The emptied pool was the set for an a cappella musical scene in the 2012 film *Pitch Perfect*.

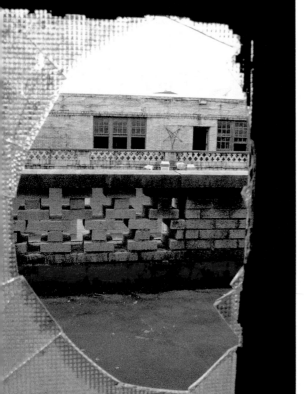

Left: The pool's signature plus-sign shaped openings in the bricks, seen here with a pentagram, 2009.

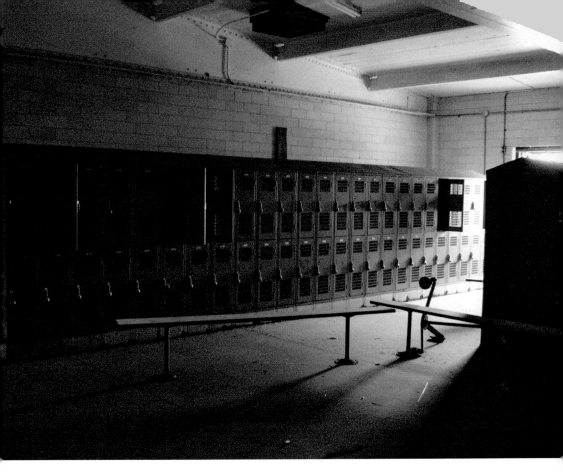

Above: Locker rooms, pictured in 2009.

Below: Originally handball courts, these later became racquetball courts, although Dooley said no one knew what racquetball was in the old days. In keeping with the pool's nonconformity, "I don't believe those courts were any kind of regulation size," he said. In 2009, the court floor sported this shout-out to Satan.

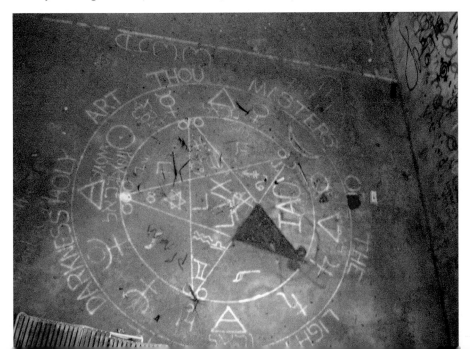

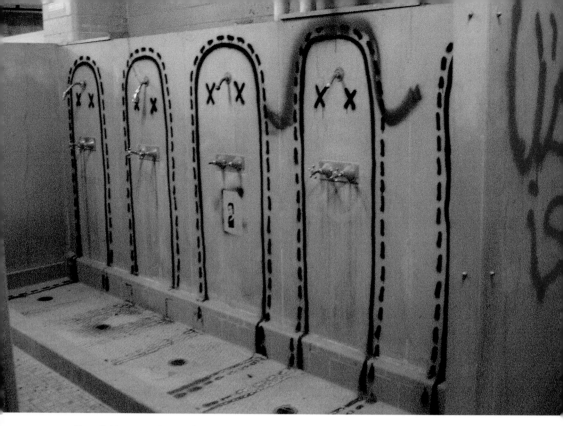

Above: Subterranean showers. There are a few other quirks to this pool. Bill Bankhead notes the building is located on a former bank of the Mississippi River. It's level at the front Field House area, but drops down in the back, "so the pool is actually suspended," and you can walk in a tunnel all the way around it. Mike Dooley heard that the pool had a false bottom to curb leaking problems, which also contributed to it being too shallow for proper diving.

Below: The Field House, LSU's first student union, is still very much in use for classes, but needs a lot of repair work.

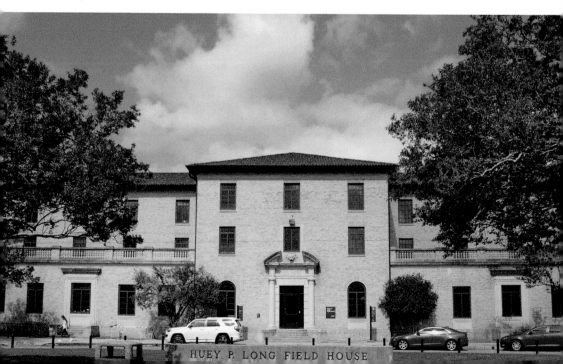

HUEY P. LONG FIELD HOUSE

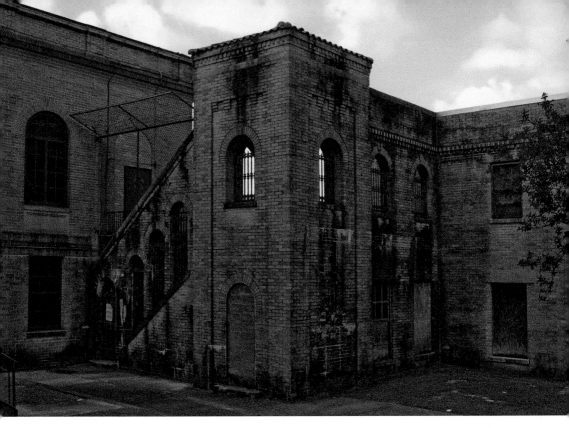

Above: The exterior of the pool structure at the rear of the Field House in 2018. It has become more noticeably neglected on the outside in the past decade.

Below: The pool in 2018, viewed from the Field House's former ballroom, now a dance studio.

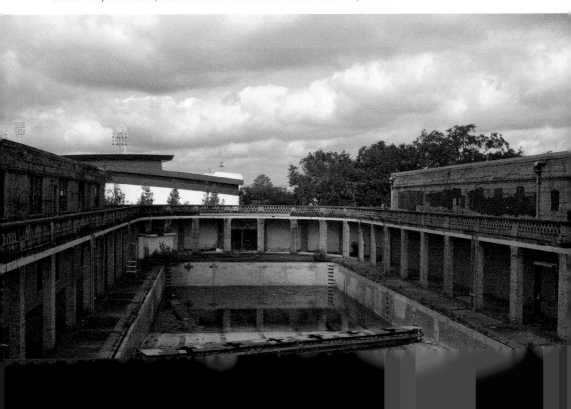

3

DESOLATION ROAD

In its day, the River Road along the Mississippi River between Baton Rouge and New Orleans was an impressive route for motorists to meander one hundred scenic miles. They could make their way along one side of the big river and drive back along the other, passing the elegant plantation homes of some of the wealthiest families in the state.

There are still many points of interest for day trippers along this lazily winding scenic byway, including macabre ones, like the (once abandoned) Indian Camp Plantation in Carville which became a leprosy quarantine hospital in 1894 for 104 years, and is now the National Hanson's Disease Museum. On some rural stretches of the road past grazing cattle, where the only sound is buzzing insects, it's easy to feel transported back in time.

But there was a period of maximum Southern Gothic when, as the region grappled with the post-war economy and the obsolescence of the plantation life, it was unclear what would become of many of the grand dame residences along the river.

Many plantation houses were taken by war, the changing banks of the river, fire, and time. But some of the ill-fated homes took a prolonged exit, languishing in ruin for years. So if you imagine traveling along River Road in the 1920s, 30s, or 40s, you would see one after another, once-magnificent residences given over to decay and being overtaken by plant growth.

In some, human squatters seized their opportunity to live in a big house, as others sadly also did in surrounding slave shacks. Other mansions housed animals. A 1940 article in the *Times-Picayune New Orleans States* paints this picture: "Rooms in which aristocrats once danced and coquetted are used to store hay or to stable cows."[1]

Many of the residences had unique extravagances, a well-known example being Valcour Aime in St. James Parish, also known as The Refinery, as it was the first plantation in the country where sugar was refined in 1834, from brown to white. It was famous for its garden, which at several acres enclosed on three sides with a brick wall, was more like a park, giving it another name, Le Petit Versailles. The gardens are reported to have featured the first palm tree imported to North America, and had lakes, streams, cascades, and grottoes.

Valcour Aime was already deserted and deteriorating in the early part of last century and burned in 1920. A 1920s tribute to the home's former glory by New Orleans journalist John P. Coleman noted that "There was a room also for the wayfarer—the homeless wanderer where he could spend the night and be comfortable, eat and make merry."[2]

Of River Road's lost plantation houses, one of the only ruins still remaining, if not the only one, is the Cottage Plantation.

Located at the first bend in the river south of Baton Rouge, Conrad's Point, the Cottage was in the Duncan/Conrad family for over a century. It was built in the early 1830s by Abner Lawson Duncan, who counted among his credits being an aide-de-camp for Andrew Jackson during the Battle of New Orleans and also designing the Cottage, as a bridal gift for his daughter and son-in-law. His gift came with the plantation and slaves.

An 1859 steamboat crash on the river became part of the Cottage's history. The *Princess* was packed with passengers, pork, and other freight headed to Mardi Gras in New Orleans when it exploded near Conrad Point, leaving about seventy people dead. Some of those injured were rolled in flour on the lawn at the Cottage, as a first aid attempt to soothe burns and scalds.

Among the Cottage's distinguished guests from antebellum society were President Zachary Taylor. It served as the setting for two films, for many outdoor scenes in the Clark Gable and Yvonne DeCarlo picture *Band of Angels* (based on the Robert Penn Warren novel), and lest anyone mistake Louisiana for a newcomer to the film industry, the house appeared in several scenes from the earliest period of moviemaking, in D. W. Griffith's 1917 film *Burning the Candle*. It was also a setting in the 1945 mystery romance novel *The River Road*, which likely features accurate descriptions of the house and surroundings, because author Frances Parkinson Keyes wrote it while staying on site.

For a short time in the 1950s, the Cottage was one of River Road's survivor plantation houses open to the public for tours, until a 1960 lightning strike caused a fire that destroyed the house.

Of course, some of River Road's other plantation homes have survived, like Houmas House in Darrow (a filming location for the film *Hush, Hush, Sweet Charlotte,* also

mentioned in the Bellemont chapter), which is open to the public. Baton Rouge's Magnolia Mound, now a museum, represents a 1960s preservation victory. Further south, Ormond Plantation in Destrehan, once known for the bad luck of its owners, was formerly abandoned and broken down, but is now a bed and breakfast.

There's at least one more dark aspect to know about River Road: It wasn't only plantations that disappeared, but in a few cases entire communities that vanished, like Burnside, which was sold to the Olin Revere Metals Corp to make way for an aluminum plant in the mid-1950s. If residents didn't move their homes, they were demolished.

Parts of this byway are indisputably serene, but delving into its past shows the River Road has every reason to be populated by ghosts.

A remote natural gateway of River Road.

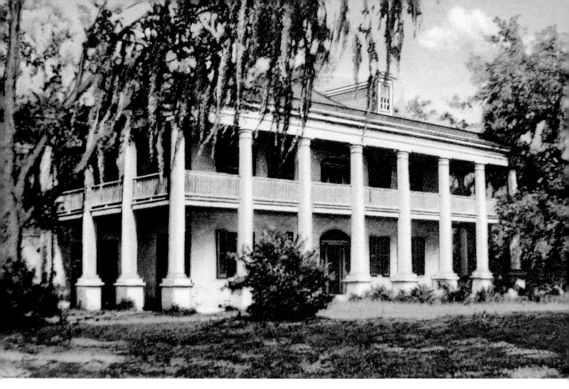

Above: The main house of the Cottage Plantation was three stories, made of white plaster over brick (which were handmade by the plantation's slaves), with green blinds and shutters, and a gray slate roof. After the 1960 fire, some of the brick walls partially remained, but now all that remains are the bases of the twelve Ionic columns of the ground-level deep-set lower gallery. A central hall led through the house to a similar gallery in the back. (*Postcard by Curt Teich Company*)

Below: Cottage ruins in 2018. There were twenty-two rooms on the first two floors, including two huge reception halls, a library, and a music room. The third floor had a few additional rooms and "a large number of intriguing cubby holes and garrett hiding places," according to a 1936 newspaper article on the Cottage. There was also a widow's walk observation platform that afforded a view of Baton Rouge in the distance.[4]

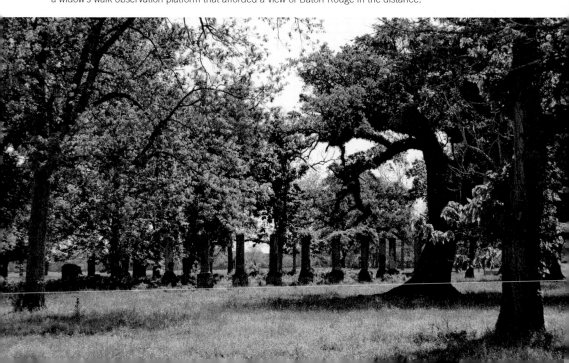

Above: The remains of the Cottage property entry. Ghost stories told of the house include eerie music of slave songs, sightings of former resident Angus Holt, and a man spotted by firefighters in a window as the house burned down, but who left behind no remains. During the Civil War, the Cottage Plantation main house was taken over by Federal forces who used it as a hospital. Many who died in a smallpox outbreak were buried in a cedar grove north of the house.

Below: The never-completed Chatsworth house in South Baton Rouge was modeled after an English country home. It was said to be haunted by a sorrowful woman who lost a child. Shown here possibly in 1900, it became a victim of a levee setback after the flood of 1927, and was demolished in 1930. (*Andrew D. Lytle Collection, Mss 2600, Louisiana and Lower Mississippi Valley Collections, LSU Libraries, Baton Rouge, La.*)

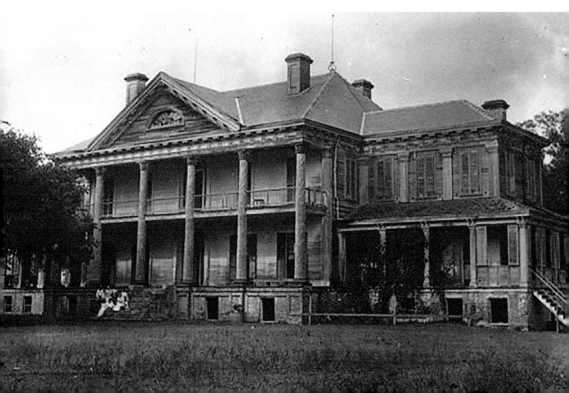

Above: A single-room shack, possibly slave quarters, photographed near Conrad Point in 2008. The structure may have been part of nearby Chatsworth. I didn't see a trace of this shack when I returned in 2018.

Below: Barthel, once a general merchandise store for one of the plantations in St. Gabriel, also had a small bar area.[3]

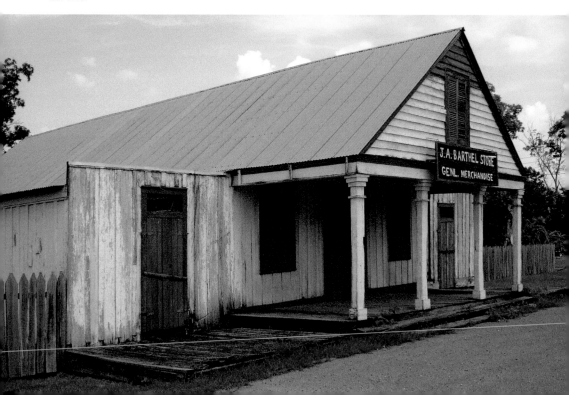

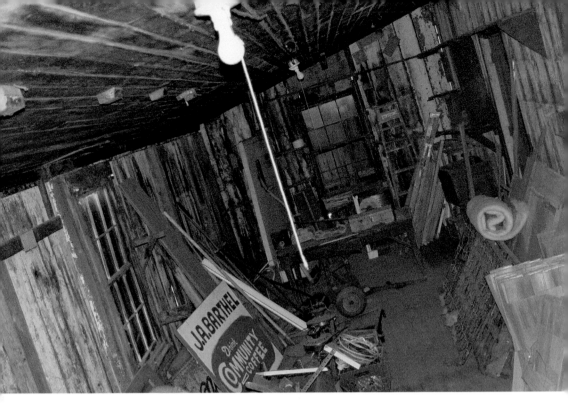

Above: The Barthel business closed in the 1990s, but when this photo was taken in 2008 it might have been kept in this picturesque state of deterioration for film and commercial shoots.

Below: An even older sign behind the old sign: it appears that a J. A. Barthel succeeded the 1880 shopkeeper, M. Barthel.

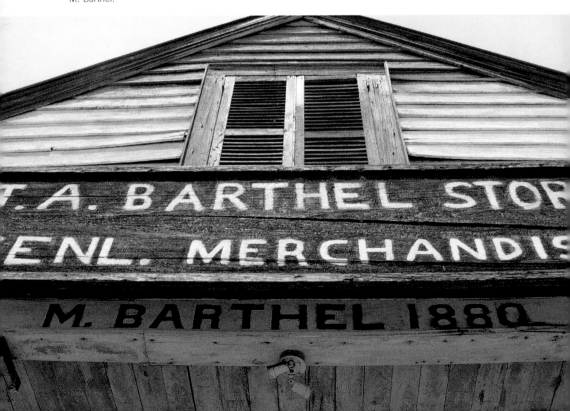

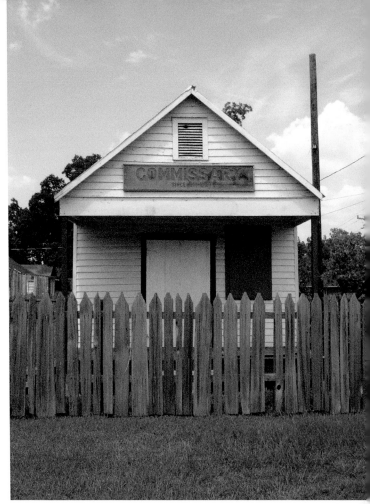

Right: Next to the general merchandise store was this commissary, photographed in 2008, with a sign reading "since 1908-1945."

Below: Belle Grove was thought to be one of the largest antebellum homes in the South. It was made of brick covered with pink stucco, and had two private racetracks. Shown in 1938, uninhabited after a failed sugarcane crop, its New Orleans-style ironwork and windows were gone, and its mantels and furnishings had been auctioned off thirteen years earlier. After decades in decay, Belle Grove burned in 1952. (*Library of Congress, Prints and Photographs Division, HABS, LA-24, WHICA V, 1--4*)

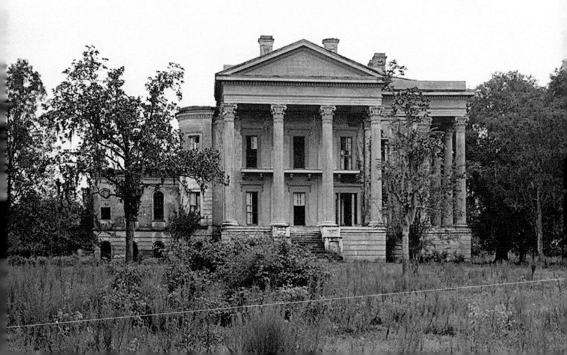

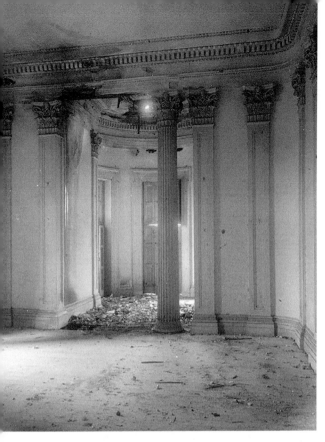

When Belle Grove near White Castle was photographed in 1938, the accompanying notes concluded with, "Slowly this symbol of American prosperity before the War disintegrates; and on a rainy day with water dripping from the ceilings in many places, you know that Belle Grove will soon be another memory." (*Library of Congress, Prints and Photographs Division, HABS, LA-WHICA.V, 1-20*)

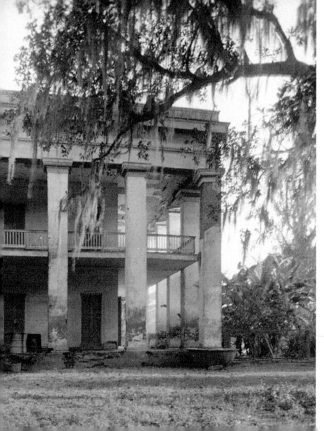

Belle Helene was built by statesman and planter Duncan F. Kenner in 1839 and was briefly occupied by Federal troops during the war. (*Library of Congress, Prints and Photographs Division, HABS LA 3-GEIM.V, 1--6*)

Belle Helene, also called Ashland, near Geismar in East Ascension parish, is pictured here in 1936 when it had been deserted for about 15 years. (*Library of Congress, Prints and Photographs Division, HABS LA 3-GEIM.V, 1--6*)

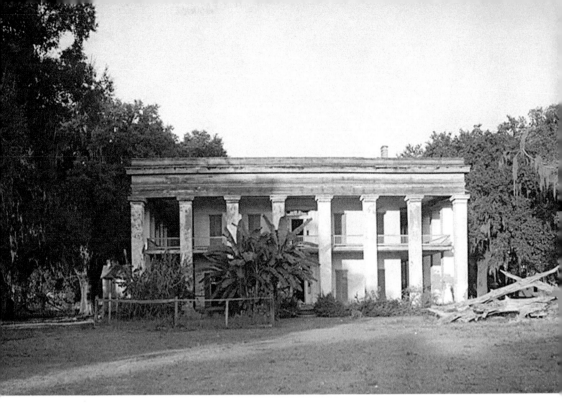

Above: Belle Helene survives today on the grounds of the Shell plant. It has served as a location for numerous movies and music videos, including *Band of Angels*, the 1957 Clark Gable antebellum drama that detractors called "the ghost of Gone with the Wind," and *Fletch Lives*. (*Library of Congress, Prints and Photographs Division, HABS LA, 3-GEIM.V, 1--6]*)

Below: The Classical Revival house known as Uncle Sam near Convent, built in 1841 or 1843, it was lost to the Mississippi's shifting banks when the levee had to be moved one time too many. (*Library of Congress, Prints and Photographs Division, HABS, LA, 47.CONV.V, 1--4*)

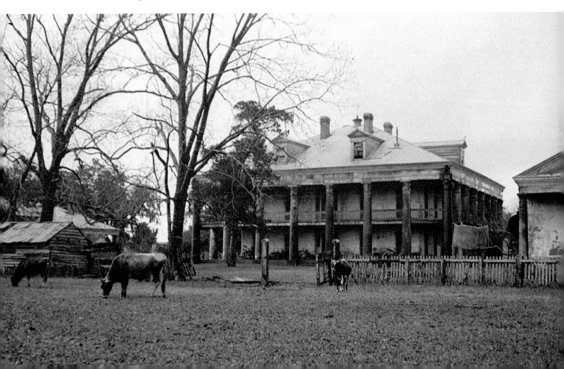

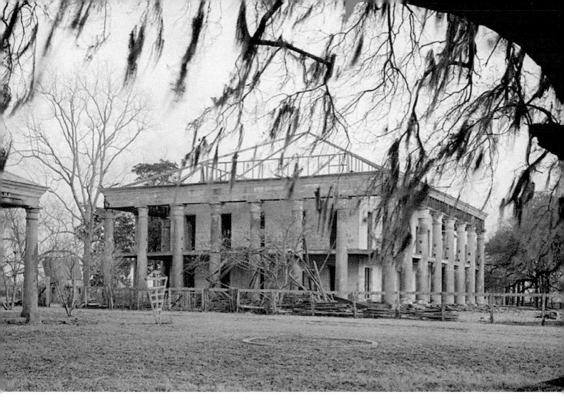

Above: A 1940 telegram from the National Park Service asking to defer Uncle Sam's demolition pending possibly making it a national monument or historic site arrived too late—demolition was underway.[5] (*Library of Congress, Prints and Photographs Division, HABS, LA, 47.CONV.V, 1--7*)

Below: The former home of New Orleans lawyer Zenon Trudeau in St. James Parish in 1938. Sadly, this unique structure was eventually demolished. (*Carnegie Survey of the Architecture of the South, Prints and Photographs Division, Library of Congress, LC-J7-LA 1319*)

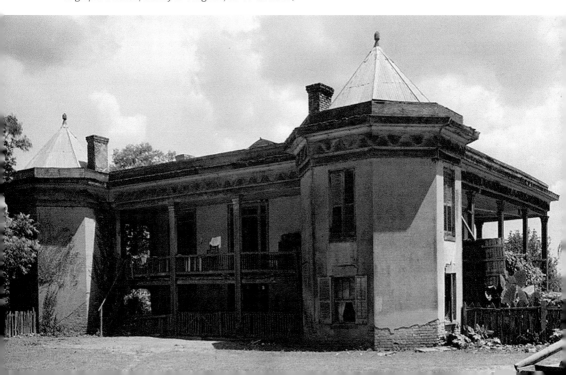

4

TWO LINCOLNS AND A SWEET OLIVE

As happened in cities across the country, the 1960s brought unrest to Baton Rouge in the form of civil rights strife, racial clashes, and white flight. Desegregation did not come expediently or smoothly to the city. However, Baton Rouge was also the site of an influential protest: America's first large-scale bus boycott.

During segregation Baton Rouge had, by necessity, many businesses catering to black customers. The Hotel Lincoln is one that still stands, adjacent to Government Street, a defunct train stop, a barber shop, and the concrete footprints of long-gone buildings. It was built in 1955 at a cost of $165,000, offering forty-six air-conditioned guest rooms.[1] The list of rumored past guests of the hotel and its lunch room includes Ella Fitzgerald, Duke Ellington, and Louis Armstrong. All of those acts, plus Cab Calloway and B. B. King, performed at the nearby Prince Hall Masonic Temple, so it's quite possible that some or all of them patronized this spot. They may have had no other choice.

Not much more information is available about the Lincoln, and despite new ownership, a restoration project is not looking likely. It's been vacant for over a decade (probably much longer), and the Google Maps satellite view shows a compromised roof.

A little more information is known about the Sweet Olive Cemetery, Baton Rouge's oldest African American graveyard, although no one can say why it began accepting new bodies again in the 1930s after closing in the 20s. It was already deteriorated enough in 1975 that the Sweet Olive Cemetery Association incorporated to restore and protect it.[2]

Unfortunately in 2018, the cemetery appeared neglected enough to include here. Every so often groups of volunteers or convicts descend on the site to hack away and

haul away Sweet Olive's overgrowth. But the efforts aren't consistent enough, plus there isn't funding to repair or maintain the old memorials. Some of the gravestones, tombs, and even caskets, are in extremely poor condition. Coffins have visibly filled with water.

However, one site significant to Baton Rouge's African American history has a team of persistent champions, and it looks like it's pulling through.

THE LINCOLN THEATER

Much more than a theater, this complex was built in 1951 in South Baton Rouge by Dr. Albert L. Chatman. On the premises were a barber shop, a deli counter, a pharmacy, offices for small businesses, and an office where community members could get health information, as well as voter registration. It became the heart of the community.

"It was a safe haven," said Brenda Perry, who grew up in the neighborhood and whose organization, the Louisiana Black History Hall of Fame, now owns the building. As a child, she went there to watch movies, meet other kids, and go to the deli.

It was in the upstairs United Defense League office where much of the planning took place for the Baton Rouge Bus Boycott of 1953, the nonviolent protest that brought the Baton Rouge Bus Company to the edge of bankruptcy in under a week. Reverend Theodore Judson "T. J." Jemison and attorney Johnnie A. Jones, Senior were key leaders.

Martin Luther King came to Baton Rouge in 1956 to study the model of the boycott, then took what he learned back to Alabama to lead the successful Montgomery Bus Boycott. There has been talk that Dr. Martin Luther King even visited those offices at the Lincoln, although no proof of this has emerged.

"What we have is attorney Jones stating that of course, yes, Dr. Martin Luther King did come to Baton Rouge and he did meet with him and Reverend Jemison," Perry said. Dr. King may not have come inside, but the strategies they developed happened on the inside.

So what happened to this hub with such significance to the African American community? Wilhelmenia G. Thompson, a retired teacher who grew up in the neighborhood, remembered it this way in a 2002 interview: "Of course with the integration and all where you could go to any theater you wanted to, some people chose to go to theaters closer to them rather than driving to the Lincoln Theater. As a result, that business began to decline."[3]

The Lincoln Theater closed in 1986. An *Advocate* file photo shows one of the final "now playing" lineups on the marquee, reading "KRUSH GROOVE / JIM BROWN / THREE THE HARD WAY" (which must have been a revival showing of the 1974 blaxploitation

movie *Three the Hard Way,* starring Jim Brown). It reopened in the 2000s, with live comedy and other programming, but closed again in 2007.

The board of the Louisiana Black History Hall of Fame is responsible for the continuing survival of this structure that could have been claimed by disrepair and exposure to the elements. The organization, which celebrates the achievements of black Louisiana natives and residents in history, literature, arts, and entertainment, purchased the building in 2009 and will eventually exhibit on the site, but first they have to save the building.

It was listed on the National Register of Historic Places in 2010. The organization raised funds through numerous sources (including $339,000 in community development block grants in 2018) and has been tackling urgent structural issues like asbestos, lead pipes, and damage from a tree falling on the building. The Lincoln Theater has a new roof and an exhaust fan was installed in the auditorium to prevent mold and mildew growth.

Perry predicts a 2019 reopening as a functional multipurpose facility offering classic films, concerts, and other live entertainment.

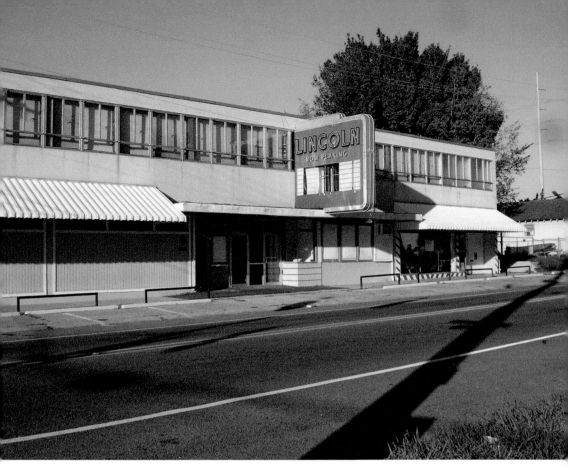

Above: On my first visit in 2007 nary a car passed in the still afternoon. The Lincoln Theater complex appeared deserted, other than the barber shop, possibly still operational by appointment.

Below: Just beyond the front doors to the right, across from the movie concession counter, was the Lincoln Deli, with prices still posted for hot dogs, po' boys, nachos, and cake.

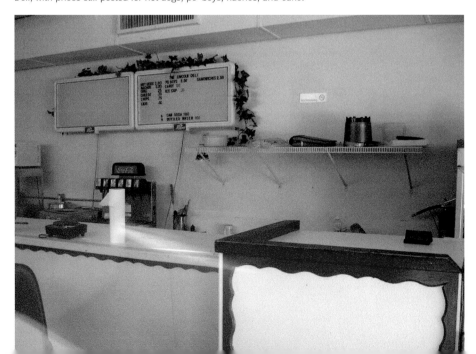

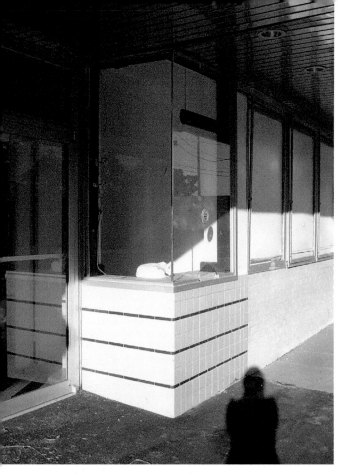

Left: The Lincoln Theater box office in 2007.

Below: The Lincoln Theater entrance and box office in 2018.

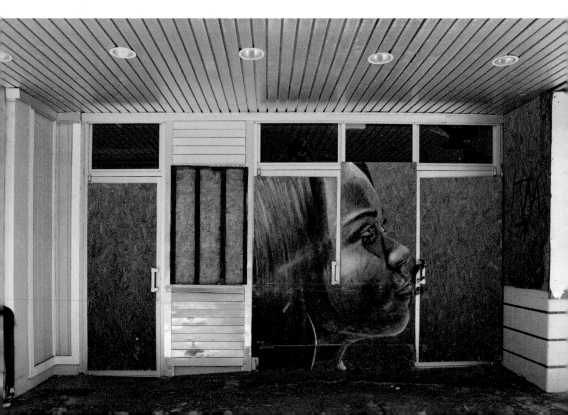

Above: History happened here: upstairs at the Lincoln, the Baton Rouge Bus Boycott of 1953 was planned. This photo was taken during a community cleanup of the building. (*Image courtesy of the East Baton Rouge Parish Library*)

Below: The auditorium sat 500 for concerts by James Brown, Chuck Berry, Nat King Cole, Otis Redding, and The Four Tops. (*Image courtesy of the East Baton Rouge Parish Library*)

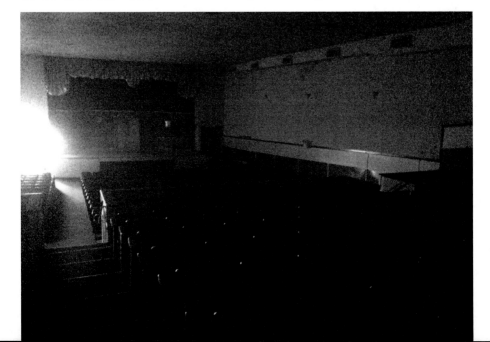

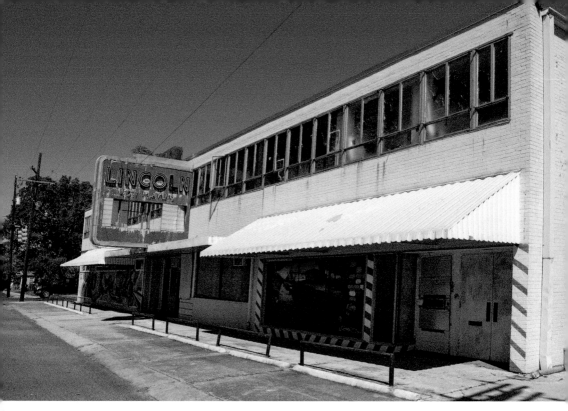

Above: In 2018, the building was looking both better off and worse off than when I first encountered it more than a decade earlier. It was now boarded up and nearly every upstairs window was broken. But there were bright new murals everywhere, and even better, there was hope, funding, and plans to reopen.

Below: "We're restoring more than a theater. We're restoring a landmark," said Brenda Perry, founder of the Louisiana Black History Hall of Fame.

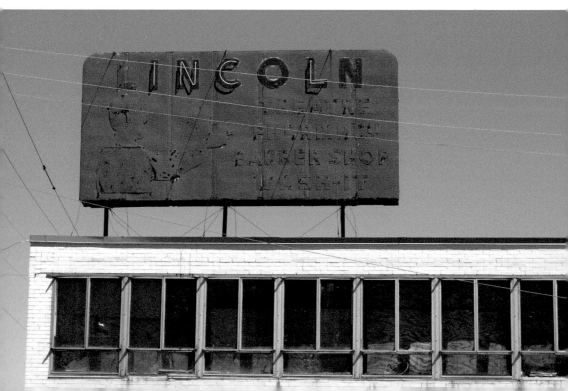

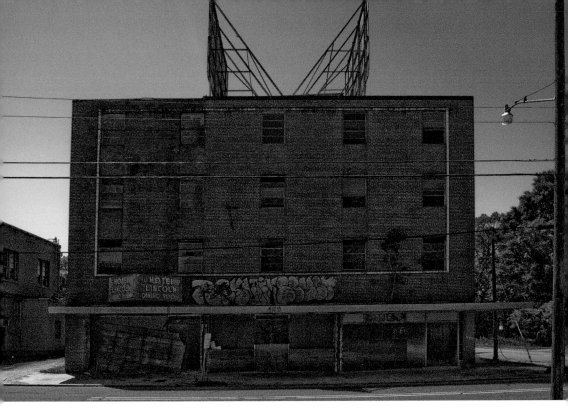

Above: Shown here in 2018, the Hotel Lincoln sold in 2017 for $400,000. In early 2018, the new owner sued the last owners, claiming they sold the building without having a clear title.

Below: Looking in the Hotel Lincoln front door in 2007. The hotel opened in 1955 and closed in the mid-1970s after integration caused business to taper off. In 1965, two unidentified white males threw dynamite at the building from a car during a civil rights event. It landed on the entrance roof, but no one was injured in the explosion.

65

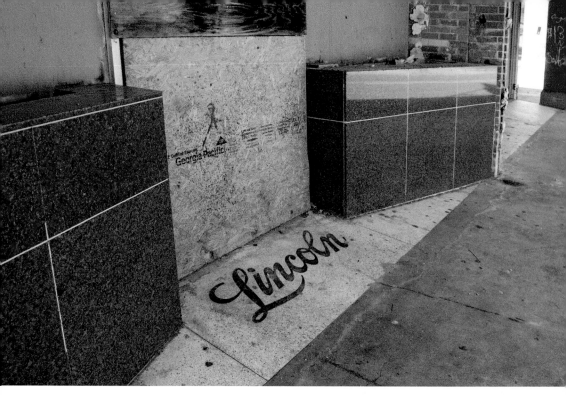

Above: Civil rights attorney Johnnie A. Jones, a leader in the bus boycott, recalled the Hotel Lincoln as "the most prominent hotel here," in a 1990s oral history interview. "That was a really popular place when it got there, because it was the finest black hotel, almost, the finest in the South." [4]

Below: Looking into a locked room at the north end of the Hotel Lincoln through a window grate, a Vietnamese phrase can be made out on the far wall. It translates to "You all will be spiritually free." In 1988, the building became St. Michael's boarding school for Vietnamese boys. A 1989 article said the school had thirty students interested in a religious vocation. It had no air conditioning and the students were not allowed to date. It was never heard from again.

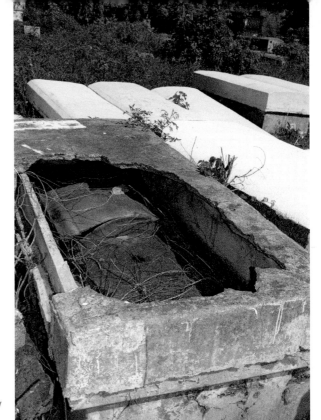

Sweet Olive, the first African American cemetery in Baton Rouge, dates to 1898, although burials might have begun before that. In 2018, it was obscured by knee-deep overgrowth.

Located at the west end of Mid-City on just under five acres, Sweet Olive was already getting crowded in the 1920s. The Board of Health shut down burials following an anonymous letter that reported a gravedigger digging the graves too shallow and sometimes burying two bodies to a grave. Well, the closure didn't *immediately* follow the letter. The investigation apparently took four years, because the letter came in 1925 and the closure was in 1929.[5]

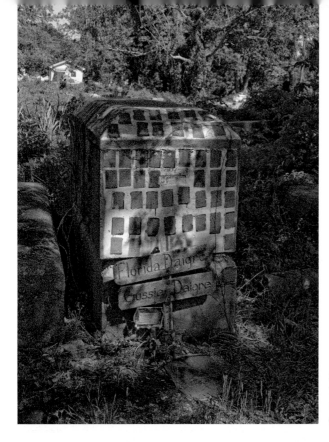

Sweet Olive Cemetery in 2018. The first burials here weren't recorded, and later burials were on top of other burials.

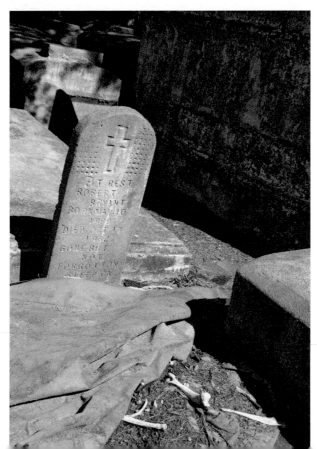

A gruesome discovery ended this 2018 graveyard visit: human bones. Maybe it shouldn't have been shocking, considering the numerous broken tombs containing broken, waterlogged coffins. But it was. It was.

5

THE GAME CHANGER

O n my first visit before moving to Baton Rouge in 2007, it was the first derelict structure to catch my interest.

There was nothing appealing about the building itself, a dingy, single-story concrete number, but I was intrigued by the ghost signs advertising old-timey spa services along the top of the exterior. "SLENDERIZING SAUNA" and "TURKISH BATHS."

What was this place?

The building started out in the 1930s as Baton Rouge's first radio station, WJBO. In its final years, it served as rehearsal space for bands.

But it was really Alvin Roy's gym.

The weight training methods he taught at Alvin Roy's Strength & Health Studios changed everything for Baton Rouge athletics, and then the gospel spread to pro sports.

"There was a man by the name of Alvin Roy," began Bud Johnson, former LSU sports information director and director of the Andonie Museum, which is dedicated to LSU Athletics, in a 2013 interview.

In the summer of '58, he had Bob Petit, Jim Taylor, Billy Cannon, Johnny Robinson, Roy Winston who was still at Istrouma High School, and Norbert Roy who went on to Notre Dame from Istrouma High School. All those guys played in the pros, you see. Bob Petit went from a skinny six [foot] nine [inches], 195-pound back to the basket center at LSU to a power forward in the pros who weighed 225 pounds. If Alvin Roy's not here—he's one of the gurus of that business—I don't think that LSU ... would have been so good because ... Taylor, Cannon, all of them were lifting weights when no one else was doing it.[1]

Weightlifting is a normal part of football training today, but before Roy introduced the athletes of Baton Rouge to weight training, the accepted theory was that lifting weights slowed down athletes and made them musclebound. Roy had learned differently when he was overseas after serving in the European Theater in 1946. There, he first linked up with Bob Hoffman, the U.S. Olympic weightlifting coach.

Hoffman helped Roy buy his health club in 1948. With no professional or college teams interested in a weightlifting program, Roy turned to his alma mater, Istrouma High School, using what the principal called "relentless" salesmanship. The coaches eventually agreed, as did their star player, the now-legendary Heisman winner, Billy Cannon. Istrouma had suffered a brutal loss to its rival, Baton Rouge High, but as soon as the lifting program was established, the team unleashed a new fury. The Istrouma football team went undefeated, won the state championship, and scored more points than any team in state history. They won five of the next seven championships.[2]

Roy then went to the LSU Tigers, who were ready to weight train, which they did at his gym on Oklahoma Street. In 1958, they were undefeated and won their first national championship.

Once the rest of the country took notice of what was happening in Baton Rouge, the big leagues came calling and Roy became the first strength coach in professional football in 1963 with the San Diego Chargers. He also became an early proponent of steroids, introducing Dianabol to his training program. It wasn't illegal then, but that remains a black mark on Roy's otherwise stellar career. The chargers won the AFL championship that year. He later trained the Kansas City Chiefs (they won the Super Bowl), the Dallas Cowboys (they made it to the Super Bowl), the New Orleans Saints, and the Oakland Raiders.

He hosted a weekly TV show on WBRZ, judged events all over the world, and an award is named for him at LSU. "He really had a touch of genius, he was one of the first to franchise health studios, and one of the first to sell high protein in weight loss products," said Roy's daughter, Astrid Roy Clements. "He revolutionized sports."

Alvin sold the studio the year before his early death at fifty-nine in 1979. The building remained a gym for a few years, run by strength and weightlifting coach Gayle Hatch, a former student of Alvin's, who was the Head Coach for the 2004 men's USA Olympic weightlifting team. Under Hatch, it became the first commercial gym to offer an Olympic-style weight training program. Then began its slow fade.

It was demolished in 2008, despite talk of preservation. A personal trainer who commented on the 2008 demolition post on the Abandoned Baton Rouge blog wrote that he had submitted a Historical Louisiana nomination form for the gym to be named a Treasure in Trouble just before the nomination deadline, then drove over to Oklahoma Street to find

the building mid-demolition. The Baton Rouge native said he had only discovered the legacy of Alvin Roy three weeks earlier. His comment was the first I heard of Alvin Roy.

Clements said that all the adjacent vacant land made the location attractive to developers. "That's OK," she said. "The building did not have any more function or purpose," although she'd like to see a historic plaque on the site or a museum exhibit.

Clements, who lived in a house behind the gym as a child, also kept souvenirs of her father's workplace. "When they tore that building down, I went and got as many bricks as I could. Those are my lucky bricks. If I ever build anything, I'll use those bricks."

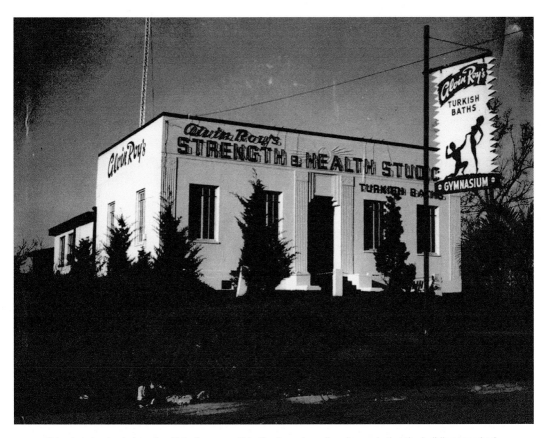

This photo is clearly from the Alvin Roy era—Alvin Roy knew branding. It reveals that the building once had neon over the painted-on letters. You can also see some of the Art Deco touches it had as the first WJBO studio, like the emblem over the door. This Deco entranceway was lost when an addition was built. That broadcasting-electricity-bolts frieze was the first round of ghost sign for this building and can be spotted in 2007 photos. [*Courtesy Roy family*]

A portrait of Alvin Roy hangs in the home of his daughter, Astrid Roy Clements, in the Country Club of Louisiana.

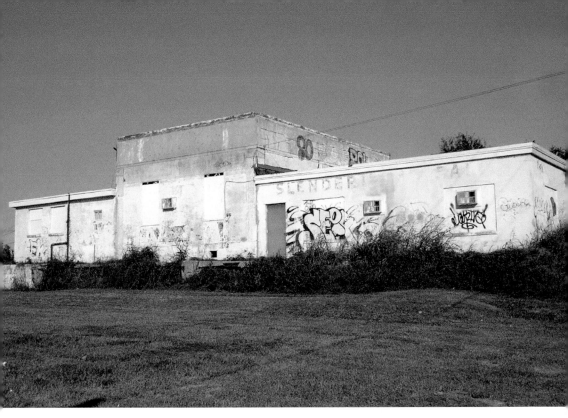

Above: A newspaper article's description of broadcasting life here in the WJBO days: "Air conditioning was only a dream, sound effects came through the windows—which were wide open to the summer air, the clank of 1934 Fords wheezing by outside, the high-pitched triumphant horns that never heard of an anti-noise ordinance, and an occasional scream."[4]

Below: In this 2007 photo, you can just make out "ALVIN ROY'S HEALTH STUDIOS" over the entrance. Alvin's brother Ray, who co-owned the gym, said in a 2005 interview that it offered massage, steam rooms, a whirlpool, salt scrubs, and a masseur from California. He also recalled TV's Ricardo Montalban working out there.[3] Donna Douglas from *The Beverly Hillbillies* also worked out during the ladies' hours.

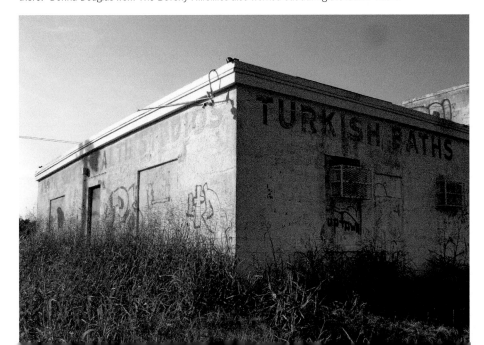

Left: Starting in the mid-1980s, the building served as rehearsal space to local bands for $125 and up per month. This door opened to a narrow central corridor with doors to padlocked rooms the bands rented, said 1985 renter Jon Sanchez, adding that the rooms were pretty cramped. Sanchez's band's space had recently been a sauna, but the benches had been lined with carpet.

Below: Jason Setzer, who rented a rehearsal space here in the early '90s, said it was a diverse mix of characters and bands who customized their spaces with colored lights, posters, beads, and rugs. "A couple of guys slept in there frequently," he said, "I guess when they were out of luck on the couch surfing circuit." The horrible smell also made a lasting impression: a blend of humidity, sweat, smoke, spilled beer, and remnant odors of the gym and spa.

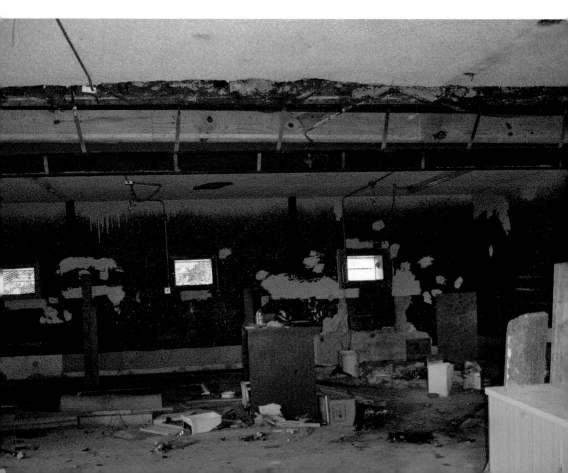

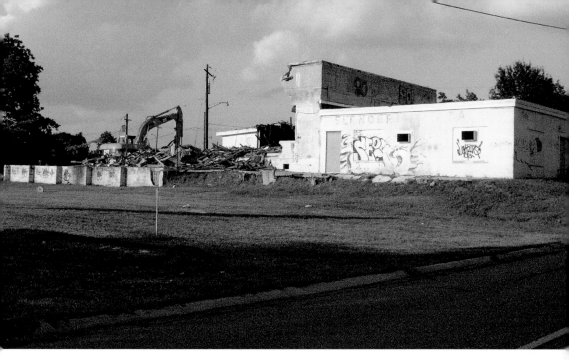

Above: "This building was one of the places where the in crowd hung out," Alvin Roy's daughter Astrid recalled. "Lots of the movers and shakers came to my father's studio, and they were his friends. There would be cars parked all down Glacier, all down Oklahoma Street from Highland to Nicholson Drive. It was like the place to go." Were any deals made here? "A lot, trust me, a lot," she laughed.

Below: The site in 2018, with new development at the left. The owner during the rehearsal studio years was Barrie Edgar, drummer of the 1960s garage rock band the Basement Wall, who also used the building to store his old touring equipment. Edgar sold the building plus a small nearby lot for $105,000 in 2007.

6

ROLL THE CREDITS ON THESE MOVIE HOUSES

As entertainment technology and audience preferences evolve, dated cinemas can update, adapt, or age their way of existence. Most of Baton Rouge's older movie theaters have taken the wrecking ball route. The Varsity by the north gates of LSU is one notable survivor of the earliest type of movie house, the plucky single screen in a walkable location. Since 1991, the 1937 Art Deco theater has thrived as a live music venue. The Lincoln Theater, discussed in another chapter, is another vintage one-screen example that is on the survivor track.

Two Baton Rouge movie houses from more recent eras didn't survive, but they lingered around long enough after closing for me to come snooping.

THE TINSELTOWN MURDER

A cinema on an end-of-the-century supersized scale, Cinemark Tinseltown USA had ten screens and was the first in town to offer stadium seating. Its 1996 grand opening ads boasted of high-back rocker chair seats and cup holder armrests for the ultimate extreme experience of beholding Sylvester Stallone in *Daylight* on 75-foot wall-to-wall screens.

Only months after Tinseltown's opening, a public murder in the rear parking lot cast a permanent shadow on the location. The sordid details evoke the Quentin Tarantino-derivative, dark bungled crime film subgenre that prevailed when Tinseltown opened.

On a Sunday night in March of 1997, Stacie Kemp Harris was shot in the passenger seat of her truck, in what turned out to be a murder for hire. She made it out of the truck and crawled for help toward her husband, who had gone to purchase tickets, but her wounds were fatal. She was twenty-four years old, and the mother of two young children.

Her husband, Tilden Harris, quickly emerged as a suspect and was arrested four days after the slaying. According to a report in *The Advocate* after the arrest, he had taken out a $100,000 insurance policy on his wife's life in January.[1]

Tilden had hired Patrick Metevia, who at 6 feet 9 inches and 240 pounds, had the nickname "Big Lurch," to make the hit, offering him $10,000. *The Advocate* reported that there were plans for Big Lurch to be Tilden's salaried personal enforcer.

Metevia didn't have a car, so he recruited Anthony Green to drive. After they pulled up next to the Harris pickup truck and saw the passenger was a woman, Metevia told investigators that he walked up to Tilden confirm the woman was who he was supposed to shoot, asking him twice. He then shot Stacie in the neck and shoulder with a pistol-grip 12-gauge shotgun.

As she was dying, Tilden was on his cell phone with the FBI, saying "They killed my wife. They killed my wife." Investigators believed this was an attempt to blame the murder on two New York men who he had previously told the FBI were threatening him.[2]

A sheriff's deputy on security duty chased the escape vehicle, which had a personalized plate: "T.GREEN." Both men bailed out from the car and a foot chase ensued. Anthony was caught after the chase, and Patrick was found the next night at a north Baton Rouge motel. Each one said the other shot Stacie.

Tilden avoided the death penalty by pleading guilty to the reduced charge of manslaughter, which prosecutors allowed because Stacie's parents said they believed he was innocent, and is serving fifty years in state prison. Stacie's mother told *The Advocate* the day after the shooting that Stacie met her future husband when she was eight, and he helped her lead her first cow in a 4-H show.

Patrick Metevia eventually admitted to killing Stacie and was sentenced to fifty years.

Anthony Green, the driver, told the court he was drunk and didn't know why they were driving to the theater. He also claimed he was half asleep when the shotgun blasts woke him up. But when the men fled the getaway vehicle, it was Green who had the gun. Thus, he was given a twenty-year sentence.[3]

More than twenty years on, the murder is still associated with the location. But did the murder doom the business, as some claim? Not according to former assistant manager John Kahl, who said that during his time at Tinseltown in 1997 through 1998, weekends were "insanely busy like a theater usually is."

The closing was a business decision. When Cinemark USA opened another theater with sixteen screens at Perkins Rowe in 2007, it closed Tinseltown. For eight years, Tinseltown sat abandoned, surrounded by its parking lot, in view of the drivers on Interstate 10, but isolated from the world.

The physical reality of Tinseltown's calling card, its stadium seating, made the building an unlikely candidate to serve as anything other than a movie theater.

It was demolished in 2015. In 2018, the site was being redeveloped into a Topgolf entertainment complex.

A HAPPIER ENDING FOR THE BROADMOOR

It was your typical midcentury, somewhat-modern freestanding movie theater in a strip mall in the suburban Broadmoor neighborhood. Former Broadmoor locals like my pal Kevin Hurstell recall seeing such cinema classics as *Herbie Goes Bananas* there when they were kids.

Built in 1965 by Gordon Ogden, Sr., who started his business with the Chimes Theater, The Broadmoor was one of eighteen Ogden-Perry movie houses throughout the South. It was billed as "Baton Rouge's largest and finest theatre" when it opened, and the advertisements boasted of a glassed smoking area and acres of free parking. The first movie shown on its only screen (the largest in town) was *Lord Jim* starring Peter O'Toole. In 1973, it became a two-screen theater, and it later had four screens and became a discount theater.

Gordon's son Randolph Ogden, whose first job was cleaning up the theater, was the final owner. One of the screens was still paired with a 1930s projector from his father's first Chimes Theater. The Broadmoor first closed in the late 1990s. It reopened in 1998 under new management, but closed again in 2004. A roof leak after a hurricane rendered the theater unviable for rehabilitation, although some other parts of the structure were still rented out to businesses. In 2015, it was the last Ogden family theater in Baton Rouge to disappear when the fifty-year land lease expired, and it was demolished.

But that wasn't the end for some parts of the Broadmoor. Sequels and reboots are everything in the movie landscape, and numerous physical pieces of the theater got their own reboots.

In 2014, Ogden sold off the stained-glass panels that once made up a colorful original design element behind the refreshment stand. About seventy of the 100 pieces total went to local chemical engineer Kim Hooper who also works with stained glass, who

paid around $400 for them. She used them to make a stage backdrop for Scale the Summit, a Texas prog band managed by her cousin, for their tour, although they were only used for one show.

The instantly recognizable Broadmoor sign also remains in the entertainment business. Just before demolition, *Dukes of Hazzard* star John Schneider purchased the freestanding sign, some theater seats, and the popcorn machine for his studios in Holden, on the site of the former Camp Singing Waters. The seats were installed in the site's converted barn theater.

A 2015 *Times-Picayune* article reported that an office park would rise in the place of the theater, but in 2018 the former building site remained a barren parking lot. The only vintage elements left were some Johnson-era parking lot lights. Across the lot, the rest of the strip mall, which was largely vacant during my first visit, had revitalized, with a Hi Nabor grocery store anchor.

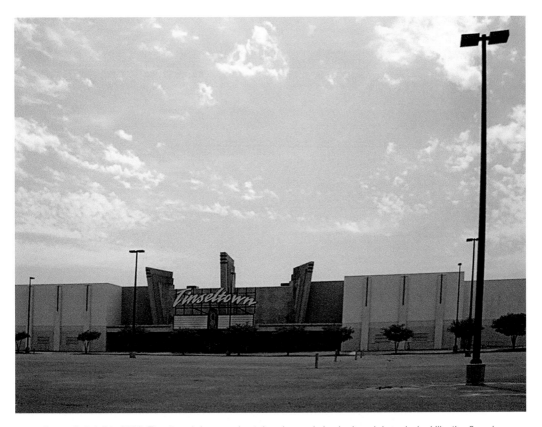

On my first visit in 2009, Tinseltown's hyper-upbeat day-glow and checkerboard decor looked like the *Saved By the Bell* diner ate some ecstasy and mated with *Pee-Wee's Playhouse*. It had zero outward indication of the murder-for-hire linked with the site.

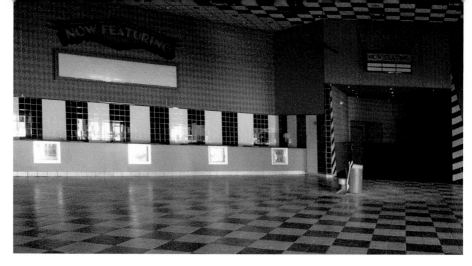

Above: Tinseltown's lobby and concession area. Closed for two years when I first visited in 2009, it was the cheeriest-looking abandoned site by far.

Below: I discovered this chalk marriage proposal on my first visit to Tinseltown in 2009. Tara herself eventually posted a comment on Abandoned Baton Rouge. She said yes! According to the comment (I was unable to track her down to confirm), she and her husband had met on a blind date at Tinseltown and he brought her back there, saying that that the cinema was reopening. She saw the chalk proposal, turned around, and he was on his knee proposing.

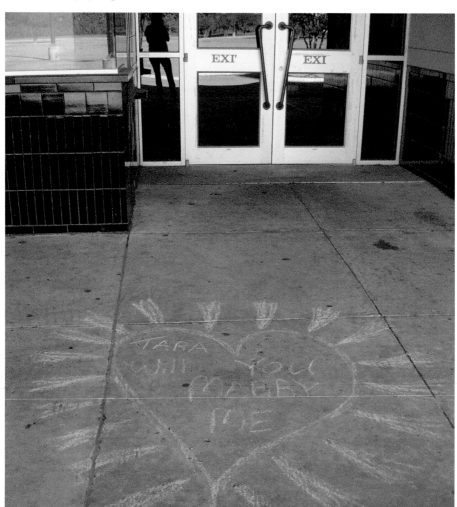

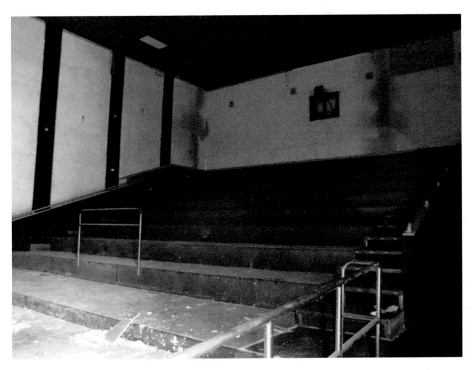

Above: An unlocked door led from the Tinseltown parking lot into this theater in 2011: it was not welcoming. Seats removed, total, clammy darkness, and only a troll-sized wooden door in the wall where the screen should be.

Below: Tinseltown's box office sign in 2009.

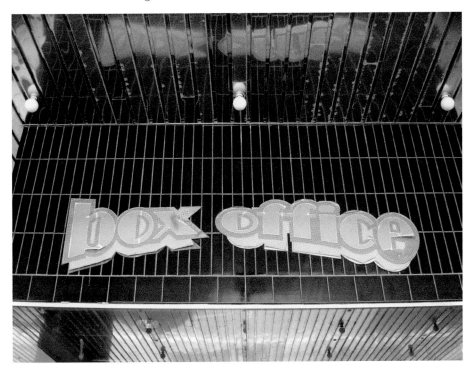

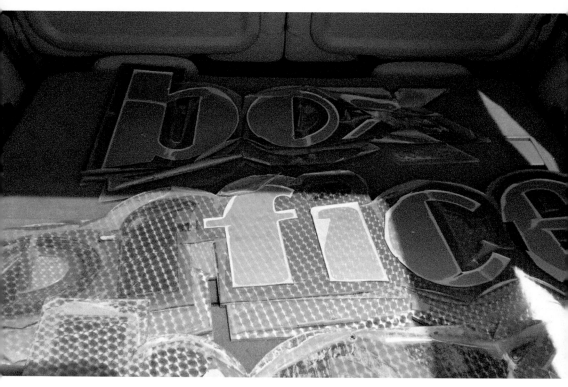

Above: Former Tinseltown assistant manager John Kahl now has two of these box office signs, after he showed up during demolition in 2015. They complement his Tinseltown collection of dozens of promotional movie posters he loaded up on during his last days on the job. A demolition crew member kept the third box office sign.

Below: A theater at Tinseltown during demolition in 2015, viewed from the former back row of stadium seating. (*John Kahl*)

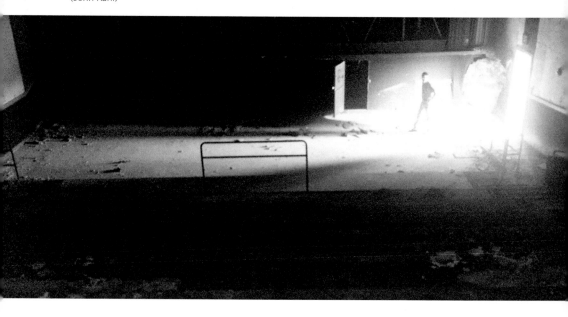

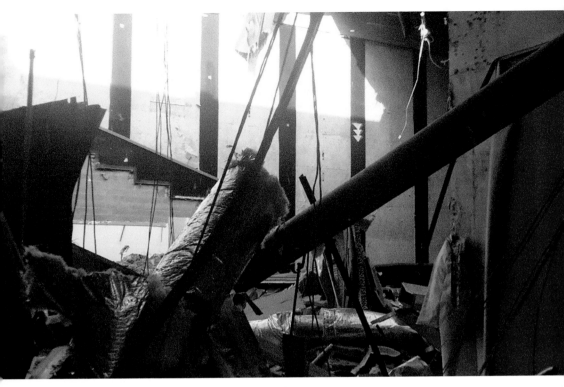

Above: Tinseltown during demolition in 2015. (*John Kahl*)

Below: Tinseltown's lobby on its way out of existence. (*John Kahl*)

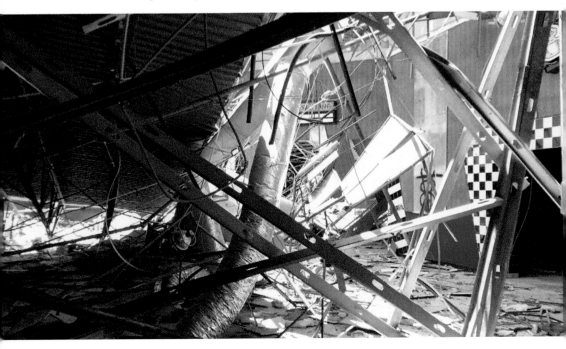

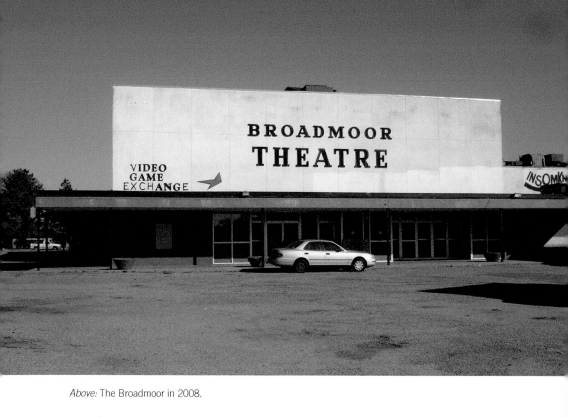

Above: The Broadmoor in 2008.

Below: Look at that swooping midcentury roofline. It cut an appealing silhouette, but like midcentury flat roofs, it was probably not great for long-term maintenance, and as it turns out, a roof leak doomed the building.

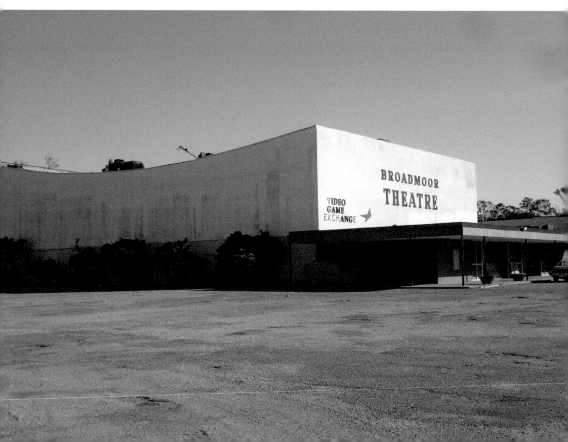

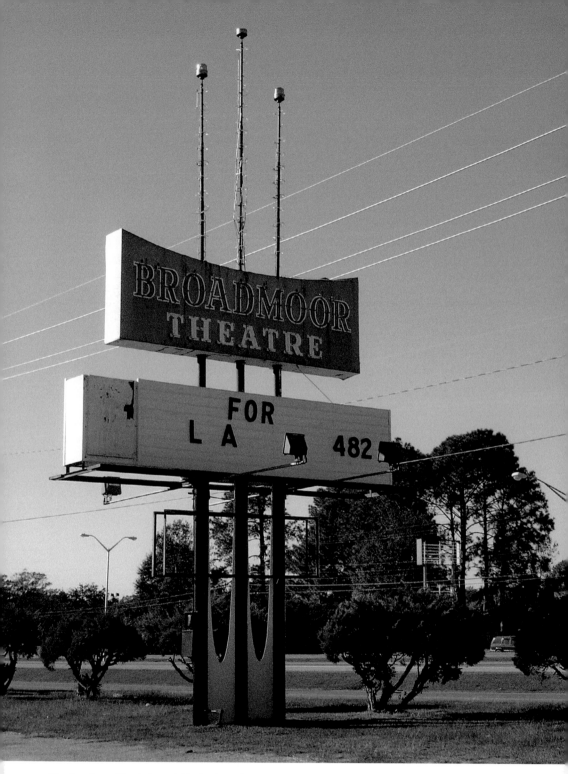

The Broadmoor Theatre's roadside sign brought a bit of Googie architecture whimsy to Baton Rouge in 1965. In 2008, its neon tubes still spiraled around the top tines of the sign. (They're no longer on the sign in its 2018 location.)

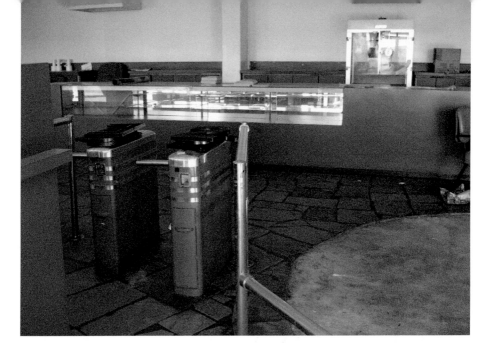

Above: The Broadmoor lobby in 2008, with a wall behind the concession obscuring the original multicolored glass installation. Note the letters and numbers for the roadside sign stacked on the turnstiles. The circular area on the floor seen at right might mark the former location of the glassed smoking area, a special feature advertised when the theater opened in 1965.

Below: These multicolored glass panels behind the concession stand were part of Victor Coursey's original design for the theater. Most of them were purchased by stained glass hobbyist Kim Hooper, who used them to make several pieces for a touring band, as well as for former Broadmoor employees, and for Coursey's daughter. Hooper and her cousin spent a weekend in 2014 salvaging the glass and framing from "decades of dust, grease, and abandonment," then cleaning it and reassembling without breaking any glass. (*Kim Hooper*)

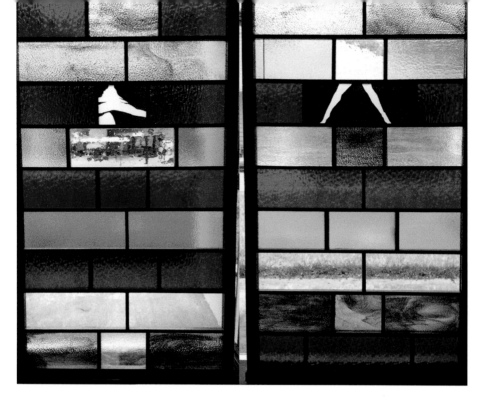

Above: Hooper's stage pieces made from Broadmoor glass. "I can remember my mom taking us to the movies as children. I loved Broadmoor's entry turnstile, the older lady with red hair giving out the tickets and yelling at the kids for running, the look and feel of a real theater, even if in disrepair. I knew that in its prime it was a big deal to watch a movie there." (*Kim Hooper*)

Below: The Broadmoor's iconic sign, plus its popcorn machine and some theater seats, live on at John Schneider Studios, the *Dukes of Hazzard* actor's residence, studios, and tourist attraction in Holden, Louisiana. (*Marshall Thornhill*)

Above: This building next to the Broadmoor Theatre opened in 1964 as the first in a small chain of I. H. Rubenstein department stores. It closed in 1979. After that, it served as Merchant's Landing flea market, before finishing out its existence cultivating a carpet of mold, ferns, and (not pictured in this 2008 photo) faded cardboard clowns during vacancy. It was demolished in 2014.

Below: In 1973, this Rubenstein store addressed rampant shoplifting with an electronic security system. During the first few days, the clerks kept forgetting to remove the tags that set off the alarms. One customer exiting with purchases set off the alarm. She was held for questioning, felt embarrassed, then went home and medicated herself. We know this today because the Louisiana Supreme Court ruled in her favor after she sued (Clark v. I. H. Rubenstein, Inc.), and she was awarded $500 plus legal fees.

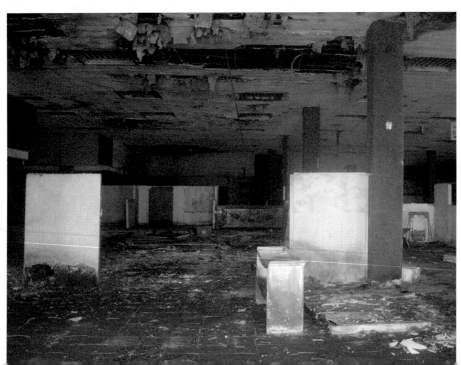

7

CINCLARE SUGAR MILL, DECOMMISSIONED

Sugar production had its United States debut in Louisiana, specifically in New Orleans, where it was first successfully planted in 1751 by Jesuit priests. It expanded to the point where 95% of sugar in the Antebellum South was produced by Louisiana.

Cinclare Sugar Mill, located just across the Mississippi River from Baton Rouge near Brusly, is one of the last examples of a South Louisiana sugar complex, once essential to the regional economy.

Established in 1855 as Marengo Plantation, the name was changed to Cinclare when James H. Laws purchased the land in 1878. The big mill structure first called Cinclare Central Factory was completed in 1906.

Additional private occupied houses between the mill and the river, the former homes of managers and workers (and also a historic district), make Cinclare another surviving rarity: a company town.

At its peak, Cinclare was self-sufficient with its own currency, store, work animals, narrow-gauge railroad, hotel, fire house with two fire wagons, dairy, butcher, blacksmith shop, greenhouse, and tennis courts.

It was one of the oldest continuously operating sugar mills in Louisiana, but when I toured the facility and grounds in 2010, it had been out of commission for five years. It was getting parted out and posing as the occasional industrial location for film shoots such as the 2008 motion picture *Mutants*. Scenes from the 2013 History Channel/Lifetime miniseries *Bonnie and Clyde* were also filmed in the Cinclare Sugar Mill Historic District.

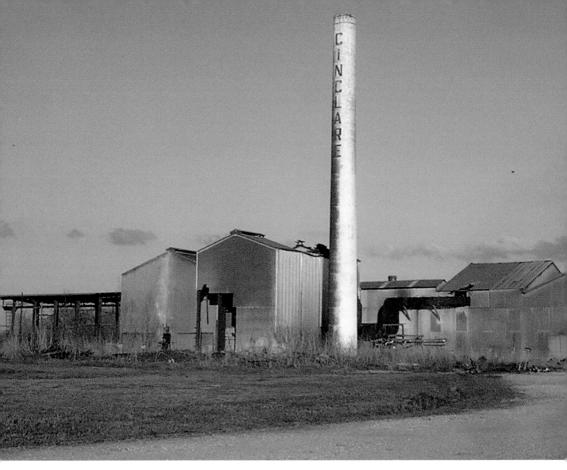

Above: Cinclare Sugar Mill, pictured in 2008. While the mill is retired from refining sugar, the sugarcane is still grown and processed on the land.

Below: Cinclare Sugar Factory, 1914. (East Baton Rouge Parish Library Digital Archive)

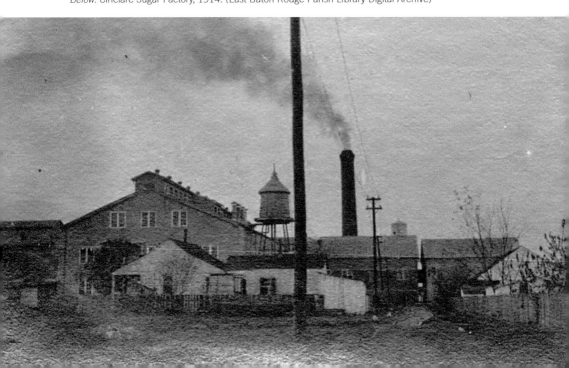

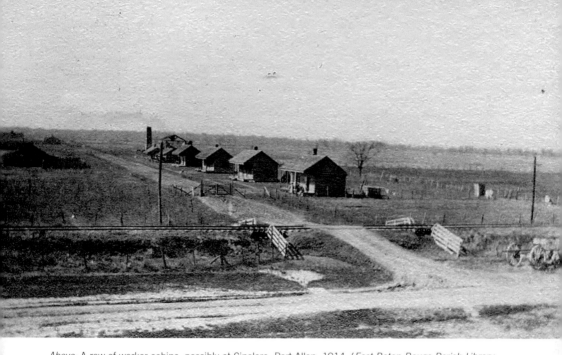

Above: A row of worker cabins, possibly at Cinclare, Port Allen, 1914. (*East Baton Rouge Parish Library Digital Archive*)

Below: Sugarcane was grown and milled on this land from 1865 until 2005. Two other Louisiana sugar mills closed earlier in 2005, at that time leaving thirteen still operating statewide.

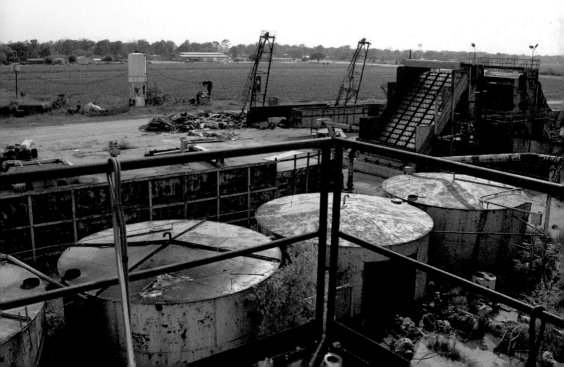

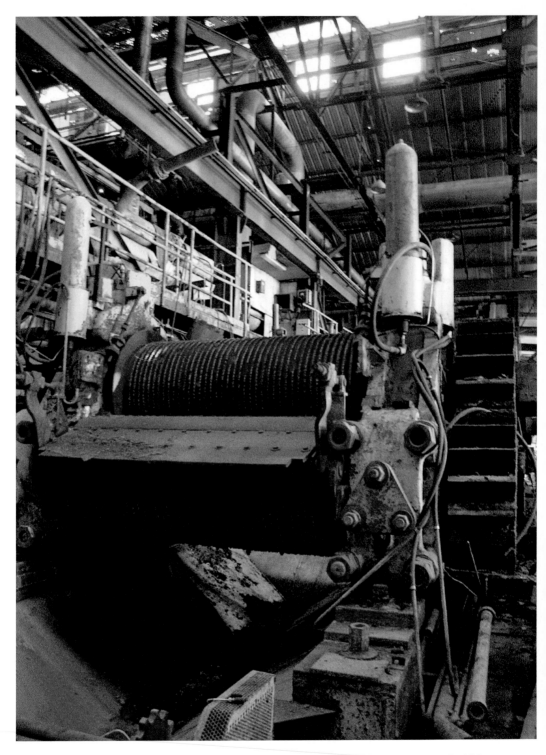

Cinclare was the last functioning sugar mill in West Baton Rouge Parish. "I live in a time warp," said Anne Timmons, wife of Glenn Timmons, the president and CEO of Cinclare owners Harry L. Laws, in 2001. Her time warp's home base was the former plantation's "Northern style" big house.[1]

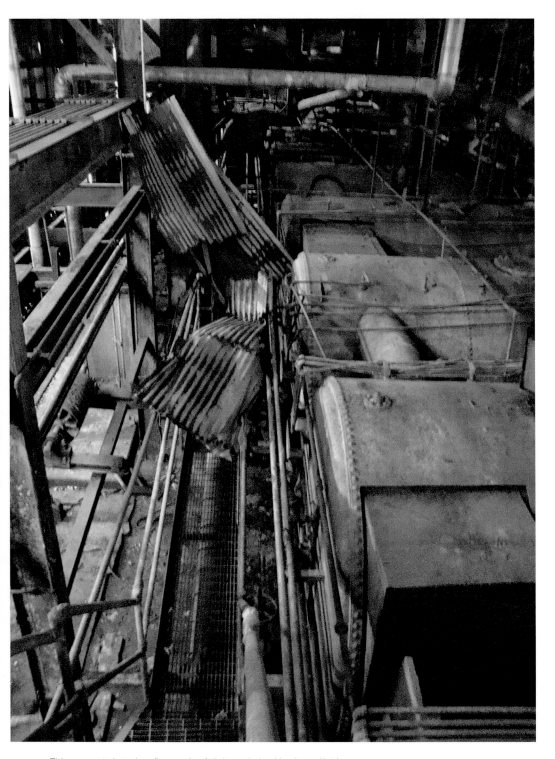

This corrugated steel roofing section fell down during Hurricane Katrina.

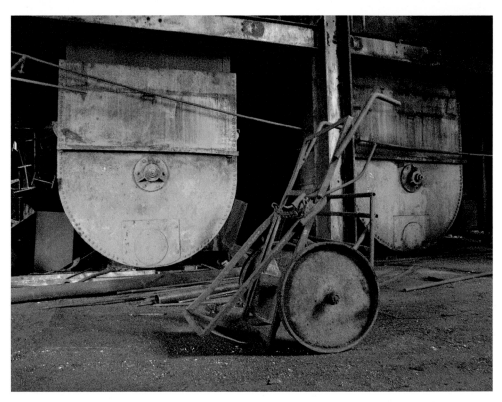

Above: Vibrantly colored tanks at the old sugar mill in 2010. Over several years beginning in 2005, Cinclare consolidated with Alma Plantation in Pointe Coupee parish.

Below: The Cinclare time clock and the remaining few punch cards in 2010.

Right: The complex is mostly intact, but the oldest building on the plantation site, a wooden structure predating the mill, burned down in 2007, before my first visit (so it's not shown here). The mill is on the National Register of Historic Places.

Below: The molasses storage tanks, shown here in 2010, held over 2 million gallons.

Above: A rusty tableau of parts inside a molasses tank in 2010.

Below: The cane room at Cinclare in 1914. (*East Baton Rouge Parish Library Digital Archive*)

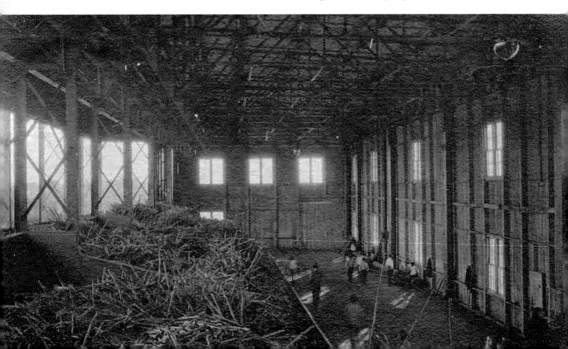

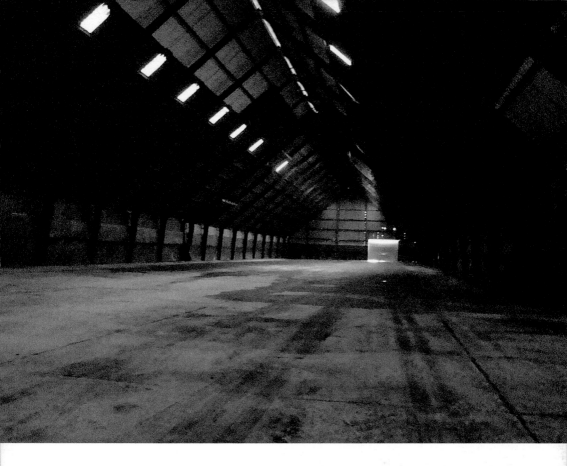

Above: Sugar storage room in 2010. I sampled a bit of sugar scraped from the wall.

Right: In 2013, Cinclare owners Harry H. Laws & Company, Inc., spent $40,000 to restore the smokestack, citing its iconic status in West Baton Rouge parish. It's pictured here pre-restoration, in 2010.

8

SOMETIMES THEY COME BACK

Not all neglected buildings can be saved, but for those that can, adaptive reuse is the salvation.

There aren't enough exciting examples of reuse in Baton Rouge, where the defaults are disuse or demolition.

However, two abandoned structures featured on my blog have made comebacks as hotels, and coincidentally, they first appeared in consecutive posts on Abandoned Baton Rouge in 2008. Both examples were also developed with tax breaks. The former Jimmy Swaggart Ministries dorm located off of Bluebonnet is one, a redevelopment that has come with fifteen years of tax abatement so far. The other is the return of a midcentury banking structure.

A variation on this is to recycle parts of an older building, as with the rebuild of the Onyx Building Downtown. The original 1950s Onyx building was the site of Rider's Jewelry Store, but it closed in the late 1970s and the building was vacant for more than thirty of the intervening years. The new Onyx Residences building, completed in 2014, incorporates over 100 panels of Carrera marble from the old structure.

BATON ROUGE SAVINGS AND LOAN ASSOCIATION

This fine example of commercial modernism designed by Bodman, Murrell, and Smith was completed in Downtown Baton Rouge in 1955, with an addition in 1961. The clock

so associated with the building now was added two years after it opened, along with a carillon of twenty-five miniature bells, identical to the chimes in the Basilica in Rome as well as at Arlington Cemetery's grave of the Unknown Soldier. Publicity at the time suggested the bells' amplification system might be used for announcements in times of civil defense emergencies or during parades.

BRSLA failed in 1985, and was bought by Pelican State Savings and Loan, which was absorbed by First National Bank of Commerce. The next occupant was Louisiana Department of Insurance, Office of Receivership.

The first period of vacancy was from 1997 through 2001, when the East Baton Rouge Arts and Technology School (EBRATS) moved in. The charter high school closed in 2006.

Reports of a potential demolition to make way for a parking lot for the courthouse came in 2010.

Architect Francisco Alecha applied for the BRSLA to be entered on the National Register of Historic Places for then-owner Bob Dean. Their case for preservation rested on the building's design, low-rise International Style, of which there are only four other early period examples in Louisiana. It employed a horizontal linear design with ribbon windows, an unornamented limestone edifice, plus that minimal graphic clock. Although many walls and some floors were tagged with graffiti at the time of application, Alecha noted the overall condition of the building as excellent.

The building was listed on the National Register of Historic Places in 2014. The building was restored in keeping with National Park Service standards and the iconic clock was returned to working order, developments made possible with federal and state preservation tax credits. The eighty-nine-room Holiday Inn Express, designed by Alecha, opened in 2015. No longer a dark corner beside North Boulevard's allee of live oaks, at night the building is lit up in blue.

Illustration from the Baton Rouge Savings and Loan Association's 1957 grand opening announcement. The BRSLA's application for the National Register of Historic Places posed that the building's location a block outside of the central business district, in the North Boulevard residential district, encapsulated the post-World War II suburban sprawl it was helping to fund.

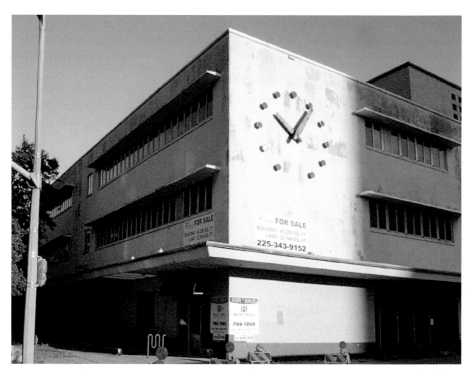

Above: The Baton Rouge Savings and Loan Association building, abandoned in 2007, with its clock stopped many years before. One commenter on the Abandoned Baton Rouge blog recalled that when he first moved to Baton Rouge in 1983, the clock was already stopped.

Below: The Savings and Loan's new incarnation as the Holiday Inn Express exists in a downtown more populated than when I first shot this building. In 2007, I could have used an antique camera with a fifteen-minute exposure time to take an exterior shot of this building. On a weekday morning in 2018, I waited for traffic to break to get the shot.

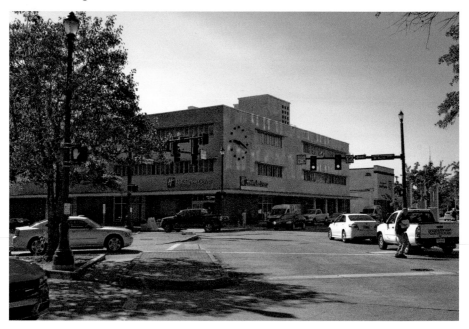

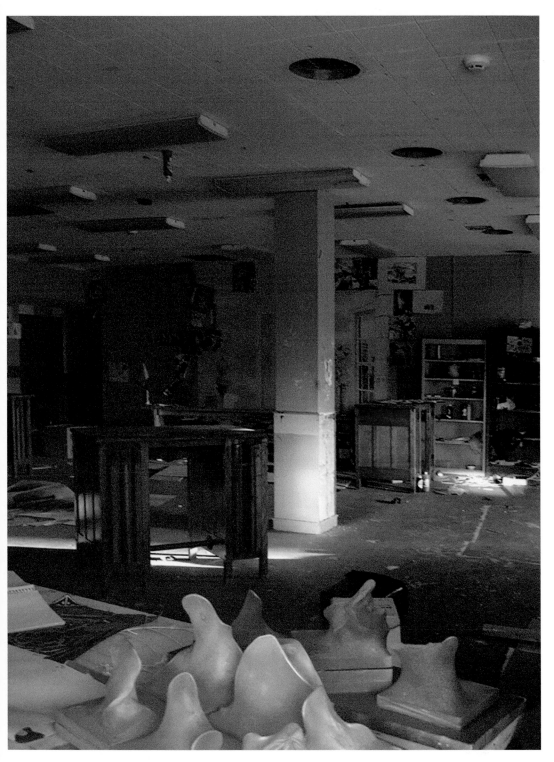

In 2007, the interior still had furnishings, murals, and craft supplies left behind by the last occupants, the much-mourned charter school EBRATS.

Left: The Baton Rouge Savings and Loan Association building held up well during its abandoned years.

Below: The Holiday Inn Express lobby in 2018. The original Tyme Stryke All Tone Machine, the carillon musical companion to the clock, still works and is displayed in the lobby (pictured at center).

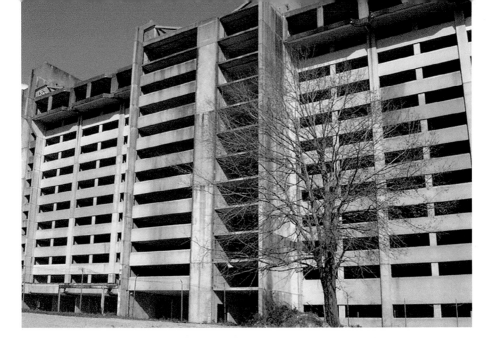

Above: This 206,000 square foot structure was intended to be a dormitory for the neighboring Jimmy Swaggart Ministries complex. Construction halted and the would-be dorm became frozen in 1989, following Swaggart's big debut sex scandal. It remained that way through his follow-up scandal in 1991, and stayed that way until several years after my 2008 visit.

Below: After two decades in limbo, the dorm shell was transformed in 2011 into this 256-room Renaissance luxury hotel with an 8,000-square-foot ballroom. The same developer later converted the 1926 State Office Building in Downtown Baton Rouge into a Marriott Autograph hotel. The scandal-plagued Jimmy Swaggart Ministries brand, meanwhile, has resurrected in the digital age as the very lucrative SonLife Broadcasting Network.

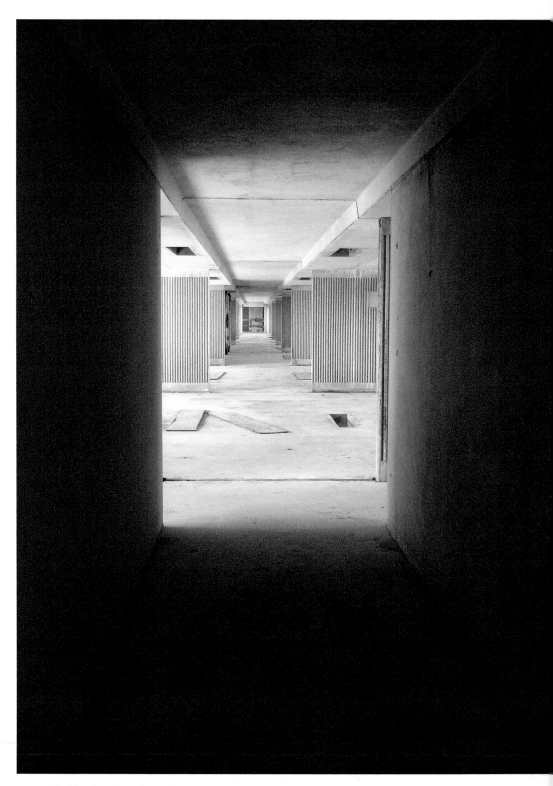

Looking down the hallway of the abandoned mid-construction Swaggart dorm in 2008.

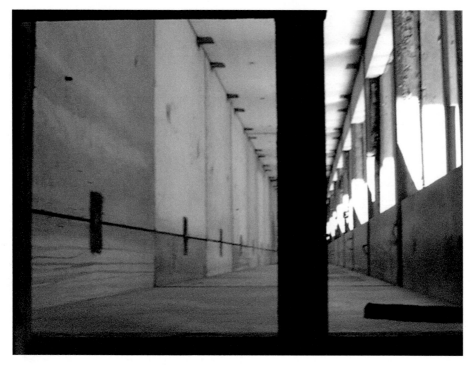

Above: A view down the elevator shaft in 2008. At the bottom was a micro-swamp.

Below: This old municipal dock, located just south of Downtown Baton Rouge on River Road, was another victim of the arrival of the Interstate in the late 1960s. Pictured here in 2008, it was half-hidden by overgrowth, and getting out to the Mississippi River-edge view meant a perilous trek over a rotten wooden walkway.

Above: Oceangoing ships used this dock to load cargo onto barges or onto rail cars, but the cause of its obsolescence, the Interstate with its freight trucking, loomed above the dock.

Below: As it turns out, that rusted old cocoon gave rise to a $22.4 million glass butterfly. This mixed-use building, completed in 2017, is the headquarters for the Water Institute of the Gulf Research and Conference Center. It's one part of Baton Rouge's Water Campus in development, and it offers a public viewing plaza over the Mississippi River. (*Trey Truitt*)

ABOUT THE AUTHOR

COLLEEN KANE is a writer who has worked at *BUST* magazine and CNBC. In between those jobs, she lived in Louisiana and created the blog Abandoned Baton Rouge. Colleen lives in Brooklyn, where nothing stays abandoned, and the Catskills, where she's explored what's left of the old Borscht Belt resorts. In the latter home, she keeps a small piece of the Bellemont's rusted decorative iron railing.

ENDNOTES

INTRODUCTION

1. Anders, Smiley, "Smiley" column, *Saturday State Times-Morning Advocate*, January 12, 2002, 25.

CHECK OUT AT THE BELLEMONT

1. Considine, Shaun, *Bette and Joan: The Divine Feud* (Dell, 1989), 364.
2. Lamb, Bobby, and Verma, Mukul, "Transcendental Group Buys the Bellemont," *The Advocate*, September 30, 1993, page 1-D;S.
3. Calder, Chad, "Buyer Considers Bellemont Options," *The Advocate*, December 11, 2009, page 01B.
4. Considine, 365.

EVERYBODY OUT OF THE POOL

1. James Monroe Smith Papers, Mss. 4490, Louisiana and Lower Mississippi Valley Collections, LSU Libraries, Baton Rouge, Louisiana.
2. Williams, T. Harry, *Huey Long* (Vintage, 1981), 518-519.
3. Gauthier, Wayne interview by Arseneault, Chelsea, audio recording, November 5, 2014, 4700.2420, Louisiana and Lower Mississippi Valley Collections, LSU Libraries, Baton Rouge, Louisiana.

DESOLATION ROAD

1. Kreeger, Mortimer (The Associated Press), "Economics, Fire, Ol' Man River Destroy Mansions", *The Times-Picayune New Orleans States*, June 9, 1940, B-2.
2. Ione Burden and Family Papers, Mss. 3063, Louisiana and Lower Mississippi Valley Collections, LSU Libraries, Baton Rouge, Louisiana.
3. Sternberg, Mary Ann, *Along the River Road, Past and Present on Louisiana's Historic Byway*, Louisiana State University Press, 2006, page 195.
4. Author unknown, "Old Duncan Home is One of Few Remaining on Mississippi," Baton Rouge *Morning Advocate*, August 30, 1936, page 12.
5. Sternberg, 168.

TWO LINCOLNS AND A SWEET OLIVE

1. Author unknown, "Lincoln Hotel Opening Here Slated Sunday," *State Times Advocate*, August 19, 1955, 32.
2. Sternberg, Mary Ann, "Baton Rouge Haunts: Tales from the Crypts," *State Times Advocate*, October 26, 1979, 124.
3. Thompson, Wilhelmenia G. interview by Rose, Julia, audio recording, June 20, 2002, 4700.1614, Louisiana and Lower Mississippi Valley Collections, LSU Libraries, Baton Rouge, Louisiana.
4. Jones, Sr., Johnnie A. interview by Hebert, Mary, audio recording, numerous dates 1993-1995, 4700.0321, Louisiana and Lower Mississippi Valley Collections, LSU Libraries, Baton Rouge, Louisiana.
5. Mahoney, Anna Lucia, "Nominating Sweet Olive Cemetery, Baton Rouge's Oldest African American Cemetery and the Preservation Process of Urban Historic Cemeteries in Southeast Louisiana," PhD diss., University of Louisiana at Lafayette, 2014.

THE GAME CHANGER

1. T. Harry Williams Center for Oral History at LSU Libraries Special Collections. Johnson, Bud, interview by Emily Nemens, audio recording, 2013, 4700.2353. Louisiana and Lower Mississippi Valley Collections, LSU Libraries, Baton Rouge, Louisiana.
2. O'Brien, Booker C. and Fair, John D., "As the Twig is Bent: Bob Hoffman and Youth Training in the Pre-Steroid Era," *Iron Game History*, Volume 12 Number 1, 36.
3. Roy, Ray interview by Hendry, Petra Monroe, audio recording, 2005, 4700.1743. Louisiana and Lower Mississippi Valley Collections, LSU Libraries, Baton Rouge, Louisiana.
4. Rivers, Bill, "WJBO: Baton Rouge's Pioneer," *Morning Advocate Magazine*, September 26, 195

This overgrown house is nearly invisible from the road in 2018, and as we approached it we spotted a car parked in the driveway. We made a hasty retreat.

Right: "Store" was formerly The Real Superstore. A 1980s precursor to big-box stores recalled fondly mostly by locals who rode in its shopping carts as kids, the site appeared abandoned for years, was used for a film shoot or two, and is now back in use by Noble Manufacturing.

Below: The picturesque rust and decay of Scenic Highway looks good on Landry's.

Some might say Scenic Highway no longer lives up to its name. I disagree.